foundation course

digital photography

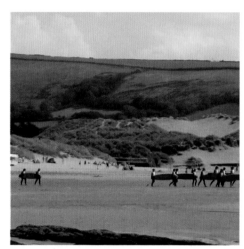

foundation course

digital photography

Steve Luck

First published in Great Britain in 2006 by Cassell Illustrated
a division of Octopus Publishing Group Ltd.
2–4 Heron Quays, London E14 4JP

Text and design © 2006 Octopus Publishing Group Ltd.

Series development, editorial, design and layouts by
Essential Works Ltd.

Distributed in the United States of America by
Sterling Publishing Co., Inc.,
387 Park Avenue South, New York, NY 10016-8810

A CIP catalogue record for this book is available from
the British Library.

ISBN-13: 978-1-844034-96-3
ISBN-10: 1-844034-96-8

10 9 8 7 6 5 4 3 2 1

Printed in China

Contents

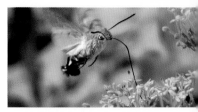

Introduction	6
Tools of the trade	**8**
Analogue versus digital	10
The digital picture	12
The camera's sensor	14
Digital cameras	16
Scanners	20
Computers and printers	22
Image-editing software	24
Capturing your image	**26**
Compact camera controls	28
Prosumer camera controls	30
Digital SLR camera controls	32
File formats	34
White Balance	36
Digital sensitivity	38
Understanding histograms	40
Scanning	42
Basic image editing	**44**
Using Camera Raw	46
Cropping	48
Rotating	50
Adjusting brightness	52
Boosting contrast	54
Adjusting colour	56
Dodging and burning	60
Sharpening	62
Removing unwanted objects	64

Advanced image editing	**68**
Making selections	70
Creating masks	78
Correcting perspective	82
Using layers	86
Adjustment layers	90
Using blending modes	94
Soft focus – street scene	98
Recreating depth of field	100
High-key effect	102
Filters and lighting effects	104
Enhancing skies	110
Adding text	114
Sharing your images	**118**
Printing	120
Adding borders	122
E-mailing images	124
Creating a slide show	126
Saving images for the web	128
Masterclasses	**130**
Hand-tinting	132
Converting to black and white	134
Creating panoramas	136
Glossary	**138**
Useful websites	**141**
Index	**142**
Author's acknowledgements	**144**
Picture credits	**144**

Introduction

Photography has changed radically over the last few years. And despite the initial suspicion of certain elements of the 'photographic community', who either complained about the inferior image quality of digital equipment or raised ethical questions about manipulating images, digital photography is here to stay.

Developments in camera technology, resulting in the latest batch of digital SLR cameras, have put paid to the 'quality' argument for most practical purposes. What's more, camera sensor technology is still in its infancy and can only get better. The question surrounding ethics is a trickier issue, but I think one that has been exaggerated. Photographers have been 'manipulating' their images since the early days of photography – from Arthur Conan Doyle's brush with the 'Cottingley Fairies' through Ansel Adams' celebrated darkroom techniques, to the use of coloured filters placed at the end of a lens. Contained in this book are some 'trickery' techniques, but if your real passion is photography your use for such techniques will quickly diminish. Capturing an image using the methods explained in the accompanying title in this series, Peter Cattrell's excellent *Foundation Course – Photography*, will always result in images with much more impact, spontaneity and resonance, than those created by spending laborious hours in front of the computer.

This book, therefore, is not about photographic technique. The first two sections of the book, Tools of the digital trade, and Capturing your image, are designed to help those who are new to digital photography to understand and make the most of their equipment. They set out to demystify the often baffling menus, dials and settings found on all digital cameras, and by doing so, ensure that when one presses the shutter release, one captures the scene to the camera's best ability.

The next two sections, Basic image editing and Advanced image editing offer an introduction to understanding and using image-editing software. They are by no means exhaustive; I have simply tried to cover the editing techniques that will help you bring out the most in the captured image, from basic cropping to emulating traditional darkroom and film techniques.

Sharing your images provides information on the most popular ways in which to show your photos to other people – whether by printing, sending as e-mail attachments, or by creating slide shows that can be enjoyed while sitting in front of the television.

The final section, Masterclasses, provides some additional ideas and approaches that you can use to further boost the potential of your images. I hope these will act as a springboard for you to seek further ideas.

In the sections containing image editing, I have used Photoshop Elements, as this is the most established software package available for keen amateur photographers, and it is also very competitively priced. The key strokes, shown in parentheses after each tool and command, provide shortcuts to the listed tools or commands, and with use will become second nature to you, saving a great deal of time.

Tools of the trade

Analogue versus digital

The debate surrounding digital and conventional analogue photography has been raging since digital cameras first became available. Historically, the debate centred on image quality, but even the lower specification digital cameras are now capable of producing excellent results up to A4. Digital cameras now outsell film cameras by a factor of 15 to 1 in some markets (and this looks set to rise), so it's clear that 'digital' photography is the future for most of us. Has the debate finally been put to rest?

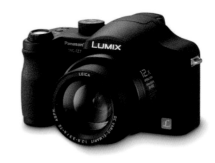

The advent of relatively inexpensive digital SLR cameras capable of producing crystal-clear A3 prints will, I think, be seen as a turning point in the film-versus-digital debate. For years digital cameras were seen as grossly overpriced and poor-performing gadgets that had no place in the world of photography – either amateur or professional. In 1995, one of the first digital SLRs cost around £10,000 and only featured a 1.3-megapixel (1.3 million pixel) sensor – less than you get in some camera-phones. The conventional photography guard was not impressed.

But the improved performance of digital compact cameras coupled with an increasing number of available outlets catering for 'digital' prints saw the consumer market switch to digital. Then in 2003 Canon announced the EOS 300D, the first affordable digital SLR. It looked and behaved just like a conventional SLR – lenses were interchangeable, there was almost negligible shutter-release delay, and every aspect of the shot could be controlled manually. What's more, the camera was capable of producing high-quality A3 prints. Now, with other manufacturers such as Nikon, Olympus, Minolta and Pentax producing affordable digital SLRs and models with full-frame (35mm equivalent) sensors, most serious amateurs and many professionals are swapping

to digital. In terms of resolution, many digital cameras now equal or even outperform their 35mm equivalents.

The digital darkroom

But, to my mind, the analogue-versus-digital debate has often missed a major point. Sure, it's perfectly understandable (and even necessary) to compare the visual output of film and digital cameras in terms of resolution, colour fidelity and tone. However, 'digital photography' is concerned with much more than just faithfully capturing a scene or a person. It is also about what can be done with the image once it is captured.

In the past, very few of us either had the time or the inclination to develop a slide or negative film and make enlargements. We simply took the film to a photo lab and the next we saw were printed photos, many of which were either blurred or over- or underexposed, or featured peculiar objects poking out of people's heads. The vast majority of us didn't have access to our film, or the ability to make contact sheets and then decide which images to enlarge and work on.

Today the digital workflow has made post-production editing available to all of us. With basic computer skills and relatively inexpensive

Digital technology has seen a host of well-known names from the consumer electronics world entering the photography market. The Japanese giant Panasonic, for example, teamed up with the lens manufacturer Leica to produce the Lumix range of cameras.

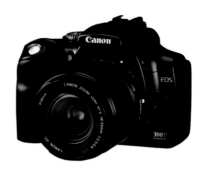

Canon's EOS 300D (known as the Canon Rebel in the United States) was the first affordable digital SLR. Compatible with most of Canon's wide-range of lenses (as well as those of independent manufacturers such as Tamron and Sigma) and other peripherals such as flash units and remote shutter releases, it showed that true SLR photography could be digital without making compromises or costing the earth.

hardware and software, we can adjust lighting levels, enhance colour, darken and lighten sections of the photo, and make prints or send images across the world – all in a matter of minutes. That's the beauty of digital photography: the entire image-making process has been put into the hands of anyone who wants to have a go.

Ultimately, the debate surrounding conventional and digital comes down to what type of photographer you are. A photojournalist who needs to send photos to a picture editor the other side of the world as quickly as possible is not going to use the same equipment as a professional landscape photographer who needs poster-sized enlargements.

But if you're an enthusiast shooting a variety of subjects, who owns a computer (although this is not essential) and wants a flexible yet efficient means of accessing the photos you've just taken with a view to editing and printing them, then digital is the way to go. Combine the quality of modern digital cameras and printers with a basic knowledge of image-processing, and you can produce excellent results. More importantly, the whole process is one that will encourage and reward creativity.

Taken with an entry-level 3-megapixel camera, this shot of a stretch of Somerset coast, southwest England, shows how far digital cameras have come since they first became available. Today's compact digital cameras are capable of producing excellent results for almost all our photo needs.

The digital picture

The unit of currency for all digital images is the pixel (short for picture element). Each pixel contains the binary information (effectively a series of 0s and 1s) that dictates the colour and tone of that particular pixel. When looked at from a normal viewing distance, the millions of variously coloured and toned pixels in the image form a picture that we see as a smooth, continuous-tone photograph.

Because all digital images are made up of millions of individual pixels, the more pixels an image has the more detail is visible. An image with plenty of visible detail is said to have a 'high resolution'. In this way, the term resolution is used to describe the number of pixels in an image, and when referring to a digital image, resolution is commonly measured in pixels per inch (ppi). So what resolution does an image need to have for it to appear to our eyes as a continuous-tone photograph?

The answer is that it depends first on how the image is going to be viewed – either on-screen or in print; and second, if in print, the physical dimensions of the print. A computer monitor has a low resolution, so for screen viewing an image need have only 72 ppi for it to appear as a detailed, continuous-tone image. If, however,

you want to make a print of your photo the resolution needs to be much higher – somewhere in the region of between 240 ppi and 300 ppi. Any significantly lower figure will result in a pixellated image, where the individual pixels become visible, which gives the whole picture an unconvincing, blocky look.

There is therefore a direct correlation between resolution and print size (see table). If an image measures 2048 × 1536 pixels (dimensions typical of a shot from a 3-megapixel camera) then the maximum print size will be around 18 × 13 cm (7 × 4.5 in). If you tried to double the print size to 36 × 26 cm (14 × 9 in) you would effectively be stretching 2048 pixels across 36 cm (14 in); and to do that you would have to print at around 140 ppi – a low enough figure to cause the image to appear pixellated.

All digital images are made up of millions of tiny squares of colour and tone called pixels. Enlarging a digital image on screen reveals the individual pixels; however when viewed at an appropriate size and from a suitable distance the pixels merge together to form what appears to be a continuous-tone image.

Each pixel in a digital image is made up of a combination of three colour channels – red, blue and green – each with a range of 256 shades. This results in a potential colour palette of 16.7 million colours.

R= 0, G=0, B=0 looks like this:	R= 157, G=46, B=46 looks like this:	R=157, G=46, B= 46 looks like this:	R=53, G=133, B= 241 looks like this:	R=255, G=255, B=255 looks like this:

Camera resolution vs. print size

Megapixels	Pixel dimensions	Print size at 300ppi
3MP	2048 × 1536	18 × 13 cm (7 × 4.5 in)
5MP	2592 × 1944	21.5 × 16.5 cm (8.5 × 6.5 in)
6MP	3072 × 2048	26 × 17 cm (10 × 7 in)
8MP	3500 × 2300	30 × 20 cm (11.5 × 7.5 in)

Colour depth

As well as resolution, a digital image needs to have a wide range of colours if it is to look natural – this is known as colour depth or bit depth (a bit being the smallest unit of data in computing). Each pixel in a digital image is made up of a combination of three channels, each representing one of 256 shades of red, green or blue. On the surface 256 different shades doesn't sound nearly enough; however, when you multiply that by three (for each colour channel) then a digital image has a potential colour palette of 16.7 million colours ($256 \times 256 \times 256$): the same as many computer monitors. This range of colours is expressed in digital terms as 2^8 (= 256), which is why it is referred to as 8-bit colour. Rather confusingly, when referring to an RGB image with its three channels, we also call it 24-bit (3×8-bit) colour. This is why you'll see computer monitors boasting 24-bit or even 32-bit colour.

The colour sensors in our eyes are most receptive to red, green and blue, and when mixed together these primary colours can reproduce all the other colours in the visible spectrum. For this reason, digital colour images are broken down into the three red, green and blue channels.

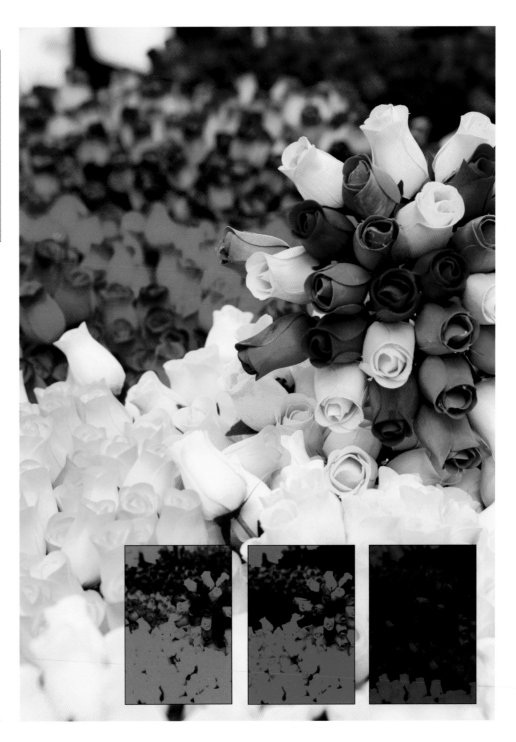

The camera's sensor

Behind the lens of every digital camera is a sophisticated piece of light-recording equipment – the sensor – which transforms the coloured light coming through the lens into electronic signals which can then be converted into digital pixel data. Although much of the technology has been around for over 20 years, it is only in the last five years or so that it has been refined to the point where it is capable of producing high-quality photographic images.

To separate out red, blue and green light – the primary colours that when combined produce most of the colours in the visible spectrum – digital sensors are covered by a colour filter array (CFA). The Bayer pattern shown here is one of the most popular CFA configurations, and uses twice as many green cells as red or blue. This is because our eyes are much more sensitive to green light than to either red or blue.

In the early days of digital photography the sensor's pixel count was king; it was the emerging digital photo industry's main marketing tool. The more light-sensitive 'photosites' a camera's sensor had, the more pixels it produced, and the higher the resolution, the greater the detail, and the bigger the prints it could form. Today, our understanding and appraisal of how sensors work is more sophisticated – we know that we should not rely on pixel count as a measure of image quality. Other issues have taken on greater significance, including the quality of the lens, the image-processing hardware in the camera, the file format the image is saved in, and the size and dynamic range of the sensor (its ability to render detail in very dark or light areas).

Surprisingly, the number of photosites on a sensor is not entirely governed by sensor size. In a quick survey of four recently released 8-megapixel cameras, one had a sensor size of 7.18 × 5.32 mm, another 8.8 × 6.6 mm, a third 22.2 × 14.8 mm and the fourth 28.7 × 19.1 mm. The first is a compact camera, the second a prosumer model, and the final two both digital SLRs. All are capable of producing good-quality A3 prints, so why bother with larger, more expensive, sensors? The answer to this is complicated, but it fundamentally boils down to the size of the individual photosites. Digital SLRs, with their larger sensors, have photosites of between 6–10 microns (1 micron = 1/1000 mm) in size, while compacts and prosumer cameras have photosites of half that. Smaller photosites are less receptive to light, have a lower dynamic range and are more susceptible to noise (see pp.38–9). For this reason, with hypothetical lenses of a similar quality a 4-megapixel digital SLR will often yield better A4 prints than an 8-megapixel compact camera. In other words, more megapixels don't always mean better image quality.

Anatomy of a sensor

The surface of the sensor is divided into millions of squares, each containing a photosite. The photosite contains a silicon photodiode (SPD) for converting light particles (photons) into electrons (the electric charge) and a storage area to collect the charge. The brighter the light, the higher the charge.

Because the photodiode can only record monochrome light, the sensor manufacturers rely on the RGB colour model (see pp.12–13) to make up all the colours in the visible spectrum. Overlaying the sensor is a colour filter array (CFA) – a mosaic of red, green and blue squares – with every one of the coloured squares sitting over a photosite. In this way, each photosite in the array filters out two colours (red, green, or blue) to capture one, and then this information is combined and 'interpolated' to create the full colour image.

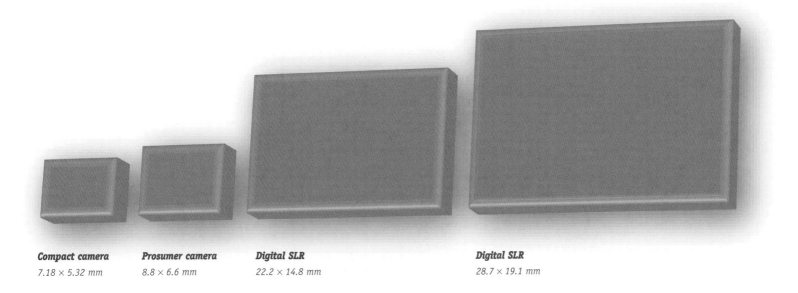

Compact camera
7.18 × 5.32 mm

Prosumer camera
8.8 × 6.6 mm

Digital SLR
22.2 × 14.8 mm

Digital SLR
28.7 × 19.1 mm

Interpolation

In practice, because the CFA has to filter out the colours, only 25% of the red and blue light is captured and 50% of the green light. (There are twice as many green squares because the human eye is much more sensitive to green than red or blue.) To make up the missing colour information, the camera uses a process called interpolation, in which the colour information from neighbouring pixels is used to 'guess' the colour value of the 'missing' pixel in-between. How good the camera's image-processing hardware is at this interpolation will play a significant part in the overall quality and colour accuracy of the image.

CCD vs. CMOS

There are two main types of sensors used in digital cameras – the first is the CCD (charge-coupled device), the second the CMOS (complementary metal-oxide semiconductor). Both types are made out of silicon, both are designed to convert light into electrical signals and both work on roughly the same principle.

In a CCD, however, the electrical charges from the photosites move down vertically and pass row-by-row to a transfer register where the charges are read out, converted to a voltage and amplified, ready to be converted into a digital signal. Once the row has been read the charges are deleted and the next row drops down to be read. Each row is coupled to the next row above, hence the device's name. The analogue-to-digital signal conversion (A/D conversion) takes place on another chip.

Because a CMOS sensor is a form of computer memory chip with a photodiode in each cell, the voltage conversion and amplification can take place at the individual photosite, without having to be passed to another part of the chip. This makes a CMOS sensor more efficient than a CCD, and it was once believed that CMOS chips produced a higher-quality image.

There are of course positives and negatives for each type of sensor, and over time both will undoubtedly improve in terms of image quality, processing time and power consumption.

Despite all having 8 megapixels, the relative size of these sensors varies considerably. Because of the direct relationship between resolution and number of pixels, it is unsurprising that the marketing departments of the major camera manufacturers place so much emphasis on megapixel count. However, we now know that a large sensor with 8 megapixels will suffer from less noise than a smaller sensor with the same pixel count.

Digital cameras

With new models of digital cameras appearing monthly, choosing the 'right' model can be bewildering. The best place to start when making your decision is to think about what you'll be using the camera for. Will you want to make high-quality A4 or even A3 prints or just postcard-sized holiday snaps? What are you going to take photographs of? Will you want to shoot short video sequences? Asking yourself these questions may not help you identify which specific camera you want, but it will certainly narrow down the selection.

This ultra-compact camera is made by Sony and features a 4-megapixel sensor. Extremely small and lightweight, ultra-compact cameras are ideal for holiday and family snaps, but few offer manual override. Not being able to manually focus the lens and select shutter speed and aperture may restrict the more creative photographer.

Although they all work in the same basic way, digital cameras can be divided into two groups; those that have a fixed lens (one that cannot be removed) and those that accommodate interchangeable lenses. Broadly speaking, fixed-lens cameras can be further subdivided into one of the following categories; ultra compact, compact and 'prosumer', while cameras in which the lenses are interchangeable are all SLR (single lens reflex) cameras.

Fixed-lens cameras

The vast majority of digital cameras available today are of the fixed-lens variety. These have been designed to appeal to a wide range of people, from those who simply want good-quality photographs with a minimum of fuss and are happy for the camera to do most of the work, to those who want more creative control, but don't want a bag full of bulky and expensive lenses. When considering buying one of these cameras think of the questions posed earlier. If you want to make A4+ prints you will certainly need to think about the megapixel count (the table on pp.12-13 will give you rule of thumb information on print size versus resolution). If you're only going to want postcard-sized prints or to view your images on screen, however, you may actually be better off buying a camera with a lower

Lens types

Focal length	Lens description
<20mm	Super wide angle
24mm–35mm	Wide angle
50mm	Normal
80mm–300mm	Telephoto

megapixel rating. Most fixed-lens cameras have small-sized sensors, and a lower pixel count means fewer and larger photosites, which are less susceptible to noise – white or brightly coloured dots that may disfigure your photograph – when you need to shoot in dark or gloomy conditions. (See Digital sensitivity, pp.38-9).

Zoom lenses

After considering what resolution is needed, most of us then look at the camera lens' zoom capability – this is usually expressed as either 3×, 4×, 6×, and so on, or as a range, such as 35mm–105mm. These last figures usually refer to a 35mm film camera lens' equivalent range.

To put this into perspective, our eyes have a field of view equivalent to 50mm. So any figure less than 50mm is considered wide-angle, while any figure greater than 50mm is considered telephoto (see Lens table). To relate the range figures to the magnification figures simply divide the telephoto figure (105mm) by the wide-angle figure (35mm) and you will get the magnification figure; in this example 3×. A 28mm-280mm range is 10×. Deciding on what range is best for you depends on your photographic interests. If you want to take standard landscape and portrait shots a 35mm-105mm (3×) is fine. If, however, you're also interested in sports or wildlife photography an extra telephoto capability will stand you in good stead, though you will pay more for a greater 10× range. Don't be fooled by any 'digital zoom' figures. All this means is that the image is magnified digitally, and will suffer from a blocky (pixellated) appearance when printed.

Size and functions

For many people the small size of many ultra-compact and compact fixed-lens cameras is an important consideration. Many professional photographers carry a compact digital camera with them at all times, as they can offer excellent image quality and their small size makes them perfect for quick candid photographs. However, as always, there is a trade-off. Many ultra compact and compact digital cameras don't offer manual override, meaning that the exposure, focusing and shutter speed are always set by the camera for preset situations. This is fine for 99% of holiday and family photo shots, but as your interest in photography grows you may become frustrated at your inability to override the presets. For example, you may want a deliberately slow-shutter speed to blur some action, or to focus only on one element of a composition. If you think that you may like to experiment, make sure that the camera can be focused manually and that it allows manual setting of both shutter and aperture. Just remember: the small size of compact and ultra compact cameras means they will usually have small sensors. You may be able to get an exposure in low-light conditions, but you might have to pay the price in terms of noise.

Finally, if you're not going to work on your images on your computer, ensure that the camera is capable of sending the images directly to a

The Pentax Optio 750Z is an inexpensive yet powerful camera featuring a 7-megapixel sensor and 4.9× zoom lens. More importantly, this model features many manual controls.

compatible printer or that it has a removable storage card that can either be given to a high-street print bureau or used directly in a desk-top printer. These days, nearly all cameras do.

For further information on digital cameras and their specific controls see pp.28–9 (Compact camera controls), pp.30–1 (Prosumer camera controls) and pp.32–3 (Digital SLR camera controls).

Prosumer cameras

In the last few years, an increasingly large number of SLR-style fixed-lens cameras has hit the market. Usually featuring powerful zoom lenses, 7+ megapixels and a wide range of automatic or manual settings, these cameras appear to offer everything a true digital SLR camera has, but in a smaller, more convenient, all-in-one form. However, sensor size is again the issue – the vast majority of prosumer models have a smaller sensor than true digital SLRs and so are therefore much more likely to suffer from 'noise' at higher sensitivity settings. This will become increasingly noticeable the larger the prints. All the same, in good lighting conditions, prosumer models are capable of producing extremely high-quality images that can, depending on the megapixel count, be exhibited at A3 sizes.

Viewfinders and video

Previewing images on fixed-lens cameras is very different to previewing a shot in a digital SLR. With some fixed-lens cameras you may need to compose your photograph through an optical viewfinder, which zooms at the same time as the main lens. Unfortunately, because the viewfinder is in a slightly different position relative to the main lens you'll only see between 80–90% of what the main lens is viewing. You can use the preview LCD screen on the back of the screen, which shows you exactly what the lens is 'seeing', but in bright light conditions this may not be easy. To combat this, more-expensive fixed-lens cameras have electronic viewfinders (EVF).

One advantage fixed-lens digital cameras have over digital SLRs is the ability to take short bursts of video, albeit at varying levels of quality. If this is essential for you, then choose a fixed-lens camera that is known for its video capabilities. Check magazine and online reviews for guidance.

Typical of many of the fixed-lens SLR-like cameras available, this Fujifilm model features a 6× optical zoom (an equivalent 35mm 35–210mm zoom), a 6-megapixel sensor, and complete manual control as well as a number of preset auto settings. Such cameras are capable of producing excellent images and are ideal for those photographers who want to take more control of the shooting situation.

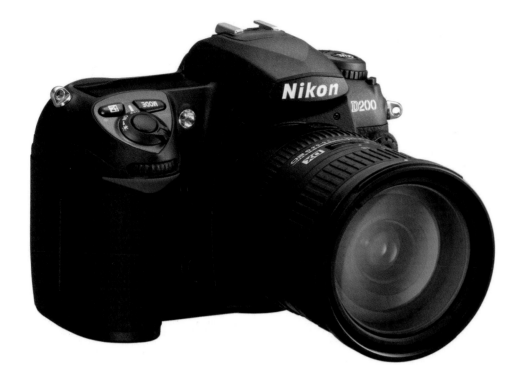

One of the latest models of digital SLRs, this Nikon camera has a 10-megapixel sensor and offers professional-level functionality. Like all digital SLRs, the lens is interchangeable, allowing the photographer to use any of Nikon's extensive range of high-quality lenses as well as compatible lenses from third-party manufacturers.

Digital SLRs

If you're serious about your photography and keen to learn more, a digital SLR should be your camera of choice. Many are now priced on a par with the high-end prosumer models, though you will probably need to buy additional lenses to get the same wide range of zoom. However, with many lens manufacturers offering 28mm-280mm or similar ranges at affordable prices you may be surprised at how accessible digital SLR photography has become. The benefits are enormous, and you will be able to produce almost noise-free images up to A3 size that show your photographic skills at their best. All digital SLRs feature manual and automatic shooting presets, and these will help you develop your skills and creativity. What's more, all are significantly more responsive than the majority of fixed-lens cameras.

Being able to change lenses also allows you to select a high-quality wide-angle or telephoto lens that has been designed specifically for that purpose (many of the lenses used in fixed-lens prosumer cameras suffer from distortion at the wide-angle end of their range, or demand longer shutter speeds at the extreme zoom levels).

In effect, shooting with a digital SLR is just like shooting with a film camera; you can view real-time action through the bright optical viewfinder, and this in turn will help you to anticipate the ideal moment for you to press the shutter-release button. When you do, there's no time lag between you pushing the button and the camera taking the picture. This is an annoying problem that even the best fixed-lens cameras suffer from to some degree, and in certain types of photography –

such as sports or nature – that pause could be the crucial difference between a missed opportunity and a perfect action shot.

SLRs and dust

The only real drawback with interchangeable lenses is that dust can enter the camera's body and settle on the glass directly in front of the sensor. The dust may be visible in the form of small blobs on your photographs, particularly in areas of flat colour, such as a clear blue sky. Changing lenses in a still, dust-free environment will help, but if it does happen there are a number of sensor glass cleaning devices available. Once you have cleaned the glass once, you will probably wonder why so much fuss is made about it.

Scanners

Surprisingly, you don't have to buy a digital camera to enjoy the many benefits of editing your own images. Many professional portrait and fashion photographers still use conventional large-format film cameras during their shoots, but then convert the developed film into digital images using sophisticated scanners. If you're happy with your existing film camera equipment, this could be your best way into digital imaging.

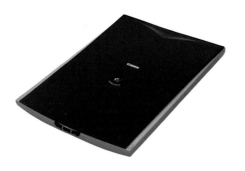

Costing around the same as a 512MB memory card, this entry-level scanner from Canon is capable of scanning prints to a good standard. It offers a maximum resolution of 600 ppi (on the low side, but still perfectly useable), but an impressive 48-bit colour depth. Its small size and ease of use make it ideal for those who want a simple scanner to digitise existing photographs.

Just as digital camera technology has improved dramatically over the last few years, so too has scanner technology – although this is not surprising when you consider that much of the technology is shared. Most scanners, for example, use CCDs similar to those found in digital cameras to capture the digital image. However, where a digital camera's sensor captures the entire scene in a fraction of a second, a scanner scans a photograph, transparency or negative one tiny line at a time.

Facts and figures

Just like digital camera manufacturers, scanner manufacturers throw around confusing facts and figures to persuade us of the merits of their product. These are the issues that you really need to concern yourself with:

Resolution

As with digital cameras, scanners are often described in terms of resolution. However, unlike digital cameras, a scanner's resolution is given using two figures (for example, 2,400 × 4,800 ppi). The first number is the optical resolution of the scanner's sensor, while the second is a measure of how finely the scanner head moves over the image. The first figure is the more important of the two, and the figure you should have in mind when buying a scanner. And be warned: you may see extraordinarily high

resolution figures running to the tens of thousands. Ignore these as they only refer to the scanner's maximum interpolated (digitally enhanced) resolution, and bear little relation to the scanner's real-world performance.

Colour depth and dynamic range

The scanner's ability to record tone and colour is every bit as important as its resolution. The minimum colour depth you should consider when buying a scanner is 24-bit. As explained on pp.12–13, this means the scanner can capture 16.7 million colours. While this is adequate for producing family snaps, look for a scanner offering 36-, 42- or even 48-bit colour depth, particularly if you want to exhibit large colour prints. Although our eyes cannot differentiate between the trillions of colours a 48-bit scanner can capture, the increased colour sensitivity makes it better at capturing subtle shadow information and images with lots of rapid colour changes. The additional colour information also becomes useful if, when editing your images, you need to make quite drastic colour corrections. With more data to work with, you are much less likely to lose highlight or shadow detail.

An effective scanner also needs to be able to differentiate subtle colour changes in very dark or bright areas of an image; this comes down to the scanner's dynamic range. Dynamic range varies from 0 (pure white) to 4 (almost pure black). If you're scanning colour prints, look for

a scanner with a dynamic range of around 3+, but if you're scanning film, which is capable of recording even more subtle colour changes, look for a dynamic range of 3.8+.

Flatbed or film scanner?

Now that you're equipped with a little knowledge, what else should you look for in a scanner?

There are two main types available – flatbed and film scanners. If you are only going to scan negatives or transparencies and want near-professional quality scans then a dedicated film scanner is ideal. While being more expensive than flatbed scanners and, of course, unable to scan photographs or other documents, film scanners have the resolution, colour depth and dynamic range to capture all the detail and subtleties of tone and colour that come with film.

For a more flexible option – particularly if you will need to scan prints or other documents (and even three-dimensional objects) try a flatbed scanner. Some scanners of this sort even come with a transparency adaptor for scanning negatives, transparencies and slides; moreover, many mid-priced flatbed scanners will make an excellent job of doing so. However, if you are going to use a flatbed scanner to scan film, we recommend you use one with a resolution of no less than 3,200 ppi (and preferably 4,800 ppi) with a minimum colour depth of 36+ bits. For scanning prints a resolution of 2,400+ ppi and a colour depth of 32+ bits will be sufficient.

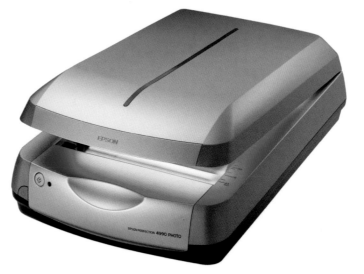

Despite being a flatbed scanner, this Epson model can also scan film negatives and transparencies of various sizes. With its maximum resolution of 4,800 ppi and a claimed dynamic range of 4.0, you can expect near professional-quality scans.

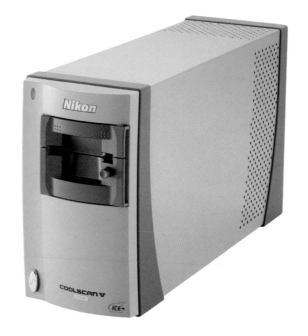

There are a number of dedicated film scanners on the market, which are designed to provide extremely high-resolution scans with good dynamic range. They tend to be more expensive than flatbed scanners, and as they cannot scan prints or other documents, are not so versatile.

Computers and printers

To make the most of your digital images – whether they have been captured directly from a digital camera or scanned in from prints or film – you will find that you get the best results if you process and polish them using an image-editing programme. To do this, you will need a computer. And once you're happy with your image on screen, you may well want a print of it to frame or show around. In that case, you will also need a decent printer.

Apple's Mac computers aren't just beautifully designed. The Mac OS X operating system has built-in tools to make the life of the digital photographer easier.

A good inkjet printer turns your home computer into a high-quality photo development lab, offering you creative control of the whole process.

As a rule of thumb, if you bought your computer after 2003 then you're likely to have a machine that can run most image-editing software, and a large enough hard disk to store hundreds of images. If, however, your computer is older, check that it has the following specification:

- a minimum RAM of 512MB (to run the image-editing software)
- a hard drive of at least 20GB (to temporarily store your images)
- a USB connection (via which you can download your images)
- a CD ROM drive (to download the software)
- a recordable CD-RW drive to burn CDs (so that you can backup your images)

If your computer is lacking any of these you will probably need to buy a new one, and you will quickly discover that the more money you have to spend, the higher the specification of computer you can afford. A faster processor and more RAM will enable your image-editing software to run more efficiently; a larger hard drive will allow you to store more images; USB2 or Firewire connectivity will allow for faster transfers between your scanner or camera and your computer; a fast CD/DVD writer will save time when archiving your images to disc. Put simply, a higher spec PC will run faster, improve your workflow, and make tedious backups a thing of the past. What it will not do is make better images.

Finally, some people concern themselves with whether they should buy an Apple Macintosh (Mac) running the Apple Mac OS X operating

A large flatscreen monitor, like this 20-in widescreen model gives you more room to work on your images and see the necessary option windows and tool palettes.

Modern Windows PCs are more than powerful enough for image-editing purposes, and are often less expensive than the equivalent Macs.

system or a PC running Windows XP. In terms of performance there is little to differentiate between them. Some prefer the slick interface and image-organisation software built into the Mac, but – with more PCs in the world than Macs – software developers concentrate on developing new products for the PC market. Mac versions follow later, if at all, so when looking for an all-purpose home computer a PC can be a safer bet.

Monitors

All recently manufactured computer screens support 32-bit colour (see pp.12–13), which means they're capable of displaying 16.7 million colours. This means that the only real issue with monitors is image-quality and size. For image-quality, look at the reviews in PC magazines; high-quality flatscreen monitors are now quite inexpensive. In terms of size, a large screen makes image-editing easier as you can have more windows and tool palettes open without cluttering the space. Look for a minimum 19 inches for a conventional monitor or 17 inches for a flatscreen model.

Printers

Modern colour printers offer excellent photo-quality results. There are two main types: the inkjet and the laser printer. Inkjets are the more popular – they're wallet-friendly, produce superb prints and are easy to maintain. Laser printers are more expensive, but the cartridges last longer making the running costs cheaper in the long term. We will see more and more affordable home laser printers in the next few years.

In terms of resolution, consider only inkjets capable of 1,400 dpi (dots per inch) or more. For laser printers, 600 dpi is a sensible minimum. All desktop printers can print a variety of paper sizes up to A4, and some high-end models produce full-size A3 prints. Some more expensive inkjets also use six or more colours rather than the usual four. The extra colours – usually an additional cyan, magenta and/or black – allow for more subtle gradations in colour and shadow detail. While this makes the cartridges more expensive to replace, the results are worth the extra cost.

Paper and inks

For high-quality prints that last, buy photo-quality paper and the manufacturer's own proprietary cartridges. Although more expensive than plain paper, photo papers don't absorb so much ink and will provide sharper, more accurately coloured images. Meanwhile, third-party cartridges may be cheaper, but their light-fastness (how quickly the colours fade) varies enormously. Be warned: any savings may come back to haunt you later.

Image-editing software

There are numerous image-editing programmes on the market – some offer only basic editing functions while others have features that you are never likely to use. The secret is to find the right package for you. At the least you will want software that can crop and straighten images, fix red-eye, make brightness and colour adjustments, sharpen images where necessary, and prepare them so that they can be shown either on screen or in print.

The good news for aspiring digital photographers is that many of the software developers are anxious for you to try their products, which is why you can download trial versions of their software (see the Web links on the opposite page).

Photoshop Elements

Despite the long list of potential image-editing software products available, one has become a favourite amongst enthusiasts. When it first appeared, Photoshop Elements was considered a cut-down version of Adobe's industry-standard professional image-editing programme, Photoshop. But over the years Elements has become a powerful image-editing tool in its own right, with each version adding new features aimed directly at the digital photographer.

As this is the software that is used for the editing projects later in this book, it is worth spending a bit of time looking at some of the main features of this excellent image-editing tool. Most other image-editing packages will have similar features.

1 *One of the great benefits of digital photography is that once the initial costs are over, taking photos doesn't actually cost you anything. For this reason, digital photographers can often end up with thousands of images that need to be organized. Downloading images to Elements is quick and straightforward, and the programme features a versatile image-organization tool called the File Browser. This allows you to view thumbnails of your photos and easily arrange them into folders and sub-folders of your own. In addition the File Browser will display the EXIF data captured by the camera during shooting, which includes such information as time and date, the shutter speed, sensitivity and aperture settings, the file size and so on. The latest version of Elements, version 4.0, also offers 'Face Tagging' – the ability to automatically recognize an image with people in it (either solo portraits or groups).*

2 | In recent years, Elements has seen huge developments in its automatic tools. These have culminated in an independent Quick Fix palette, where it is possible to adjust lighting, colour, sharpness and contrast at the click of a button. The screen can even be set to show before and after images for comparison. While still in Quick Fix mode, however, it is possible to assume some manual control by using the appropriate sliders.

3 | If the Smart Fix and Quick Fix modes do not offer sufficient control, switch to Standard Edit mode, at which point the full range of image-editing tools and menus are made available.

4 | Elements has a sophisticated help menu with tutorials on the most common image-editing tasks. In addition, all the editing tools are linked – click on the tool's name and Elements will take you to the relevant section of the help menu.

TIP

You can always try the most popular image-editing applications before you buy. Trial downloads are available at the Web links shown.
Photoshop Elements – www.adobe.com
PhotoImpact – www.ulead.com
Digital Image Suite – www.microsoft.com
Paint Shop Pro – www.corel.com
PhotoStudio – www.arcsoft.com
FotoFinish Studio – www.fotofinish.com
PhotoPlus – www.serif.com
PhotoSuite – www.roxio.com
Photo Explosion Deluxe – www.novadevelopment.com
Picture It! – www.microsoft.com

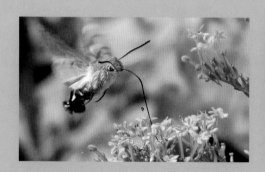 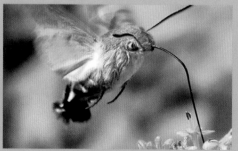 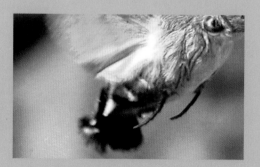

Capturing your image

Compact camera controls

There are now many excellent point-and-shoot digital cameras on the market. Such cameras have a number of automatic preset shooting modes – usually portrait, landscape, and night-time – and in these modes the camera will take complete control of the shooting situation. In benign shooting conditions the results are likely to be correctly exposed and sharply focused images. In less benign conditions you may not be so lucky.

Historically, the compact digital camera market sees more new models released each year than any other category. Stylish looks and size are important factors, and so new models are as likely to have cosmetic changes as any significant alterations to the sensor, lens or image-processing hardware. Last year's model and this year's update might be virtually identical inside.

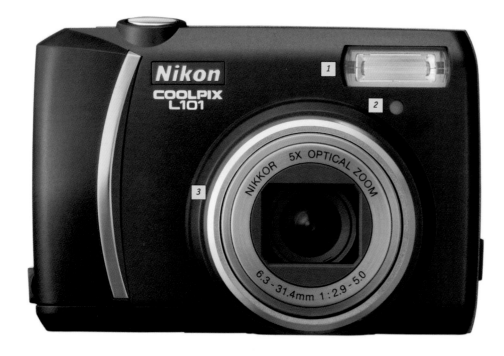

Flash [1] *Typical of compact cameras, the flash has a maximum range of 3.5m (11.5ft). Modes include Auto (the flash fires as far as and for as long as is needed for correct exposure); Auto with red-eye reduction; Off (if you don't want the flash to fire in low-light); Fill Flash (useful in daylight conditions when, for example, the subjects face is in shadow); Slow sync (useful if you don't want the flash to light a dark background).*

Red-eye reduction light [2] *This will light up for a second or two so that your subject's eyes will adjust to the light before the flash fires, so reducing red-eye effect.*

Lens [3] *This model has a 5× zoom lens, equivalent to 38–190mm on a 35mm camera. The lens retracts into the camera body when the camera is switched off.*

On/Off switch [4] *Most cameras can be set to automatically turn off after a predetermined amount of time (between 30 seconds and 5 minutes for example) in order to preserve the battery.*

Mode selector [5] *Often a small dial, but in this case a three-way switch offering Auto (in which the camera takes complete control), Scene (a series of preset modes that will help you shoot portraits, landscapes, low-light, etc.) and Movie (for capturing short bursts of video).*

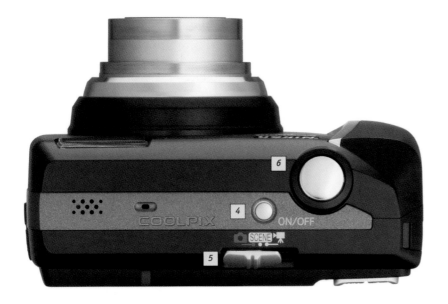

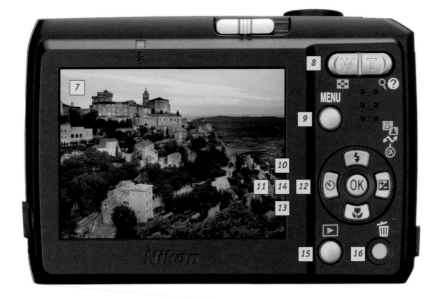

Zoom button [8] *By pressing W the camera lens zooms out providing a wide-angle field of view suitable for landscape or group shots. By pressing T the camera lens zooms in providing a close-up telephoto view.*

Menu button [9] *A button used to navigate around the camera's functions. For example, to select the Portrait mode, you would use the Menu button in combination with the information on the LCD screen to find and select the right option. Also allows you to select ISO sensitivity settings, White Balance and File Type and Size.*

Flash button [10] *Allows you to control the flash. Used in combination with other buttons you can set the flash to fire in one of the ways previously described.*

Self-Timer button [11] *Allows you to select the self-timer, which fires the the shutter release after either 30 seconds, one minute or more. The self-timer is also useful if you have the camera on a tripod (or other sturdy support) and want to avoid any camera-shake caused by pressing the shutter-release button yourself.*

Exposure compensation button [12] *This allows you to override the exposure set by the camera. This is important if you know, for example, that the subject is going to be underexposed because of the overall lighting of the scene. You can increase the exposure in short steps and check the results on the LCD screen.*

Macro button [13] *Most compact digital cameras allow you to take close-up photos. Pressing the Macro button stops the lens from trying to focus. You can then move the camera closer until your subject is sharp.*

OK button [14] *Part of the menu system, and used to set ISO, White Balance and other settings.*

Play button [15] *Pushing the Play button allows you to review your images and movies.*

Delete button [16] *Used in conjunction with the menu system, allows you to wipe any unwanted images.*

Shutter release button [6] *Most digital cameras feature a 'half way' stop. When the shutter release button is pressed half-way the camera will focus (AF) and set the correct exposure (AE).*

LCD display [7] *As this camera has no viewfinder, the LCD display is used to compose your image as well as to review photos and movies. The LCD display also acts as a user interface to navigate and select functions.*

Prosumer camera controls

Prosumer (the word is a contraction of 'professional' and 'consumer') digital cameras are aimed at the enthusiastic amateur who wants more than a point-and-shoot camera. They offer greater manual control than compact cameras, usually have a slightly larger sensor and often feature a powerful fixed zoom lens. Many prosumer models look similar to a digital SLR.

Despite the introduction of relatively inexpensive digital SLRs, the prosumer market is still growing. Many keen amateur photographers regard prosumer models as offering the best of both worlds – a flexible camera whose settings can be manually controlled, combined with a powerful zoom – and all without the cost and hassle of buying and carrying around extra lenses.

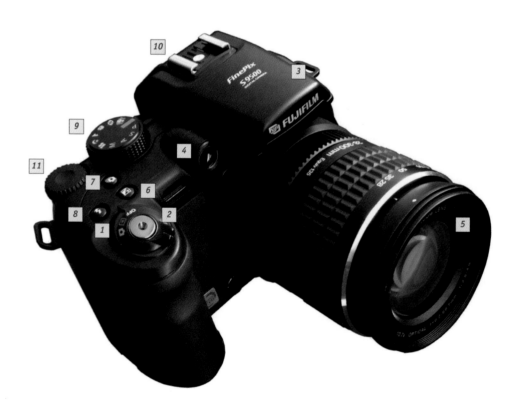

On/Off switch [1] See Compact camera controls, pp.28-9

Shutter Release [2] Prosumer cameras, like compact cameras, suffer from slight shutter delay; and although this can often be a tiny fraction of a second, it still means prosumer cameras can't match the near-instant response of digital SLRs.

Flash [3] The pop-up flash has a maximum range of 5.6m (18.4ft), which is almost twice the range of a compact camera's flash range. However, the modes provided (usually Auto, Auto with red-eye reduction, Off, Fill Flash and Slow sync) are very similar.

Red-eye reduction light [4] See Compact camera controls

Lens [5] This particular model has a 10.7× zoom lens (the equivalent of 28–300mm zoom lens in a 35mm camera). The lens is not interchangeable, which makes the lens quality of a prosumer camera a matter of paramount importance.

Exposure Compensation button [6] See Compact camera controls

Continuous Shooting Mode button [7] See Compact camera controls

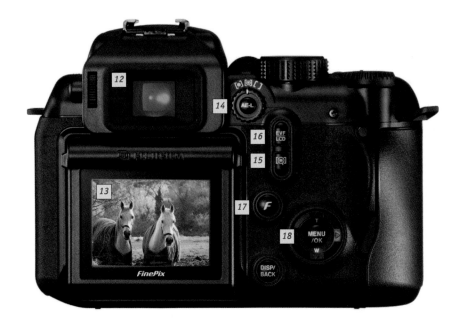

TIP

Using the AE-L button may give you a slightly underexposed subject, but image-editing software finds it easier to retrieve detail from underexposed elements than overexposed ones.

Flash button [8] *Allows you to pop the flash up so that it can be used in daylight as a fill-in flash (see Compact camera controls)*

Mode Selector Dial [9] *Similar to an entry-level digital SLR, the mode selector dial allows you to set the camera from fully automatic to fully manual. The dial also features a number of preset shooting modes, usually including sports, portrait and landscape.*

Hot Shoe [10] *This provides connectivity for external flash units. External flash units are more powerful and offer greater control than an internal flash.*

Command Dial [11] *Used in conjunction with other settings this dial allows you to alter settings or exposure.*

Electronic viewfinder (EVF) [12] *Although prosumer cameras have viewfinders, these differ from a digital SLR's viewfinder in that what you're looking at is actually an electronic version of the scene rather than a straight optical view (see Digital SLR camera controls, pp.32-33). An EVF is essentially a tiny LCD screen placed in the viewfinder, which shows more or less the same scene as the larger LCD screen on the back of the camera. The drawback with EVFs is that there is a slight delay as the action taking place in front of the camera's lens is relayed from the sensor to the viewfinder. This can make it difficult to capture fast-moving action or focus the camera manually in dark conditions.*

LCD screen [13] *With most prosumer models you can choose whether to compose your image through the EVF or the LCD screen. Often the LCD screen can rotate, allowing you to compose a photo at arm's length. The screen is also used to review images and video, as well as providing information on the camera's settings.*

Auto Exposure Lock (AE-L) [14] *Using this button allows you to take an exposure reading from one element of the photo and recompose the photo retaining the original exposure. For example, if there was a bright sky in the photo but you exposed for a darker subject, while the subject would be exposed correctly, the sky would be overexposed. Using the AE-L button ensures that you can get a correct exposure reading for the sky then recompose the shot to include the intended subject. Do not worry if the subject is underexposed (see tip above).*

Metering Selector [15] *Many prosumer cameras allow you to select which part of the image the camera should expose for. Usually the options are Evaluative (the camera will evaluate and set the exposure for the entire scene); Partial/Spot (the camera will set the correct exposure for the central element of the photo. This is particularly helpful if the subject is standing in front of a very dark or light background; Centre weighted (the camera is weighted to expose for the central subject, but will then average the exposure for the entire scene).*

EVF/LCD button [16] *Allows you to toggle between the EVF and the LCD screen depending on which method you want to use to compose your shot. The LCD screen often gives a more accurate image, but it may be hard to see in some strong lighting conditions.*

F button [17] *On this particular model the F button provides quick access to commonly altered settings such as ISO and file format and size.*

Four-way/Menu button [18] *Allows you to navigate the camera's settings, working in conjunction with other buttons when reviewing images.*

Digital SLR camera controls

Digital SLR cameras offer all the advantages of conventional SLR cameras and can produce excellent images – even in difficult lighting situations. Nor do they have to be complex or difficult to use. All digital SLRs feature a fully automatic mode, in which the camera will set the exposure, White Balance, and so on. However, in many situations, assuming manual control of all or some of the camera's functions and settings will enable the photographer to be more creative and to take higher-quality images.

One thing you quickly realize when owning a digital SLR is that you haven't just bought a camera, you've also bought into a whole system of lenses, flash guns, remote shutter releases and peripheral devices. Historically, SLR cameras were developed by companies that also specialized in high-quality lenses – the idea being that whichever SLR system you chose, you would have a flexible, comparatively lightweight camera system that could be used in just about every conceivable photographic situation. This has remained true of digital SLRs.

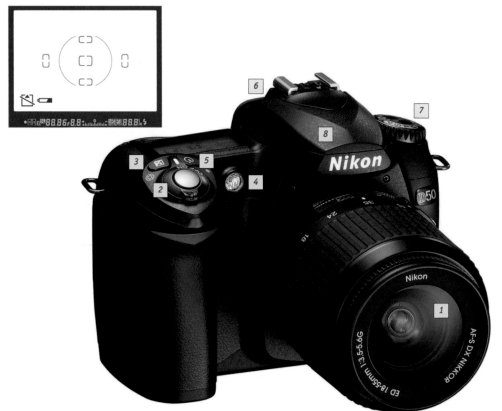

Lens [1] As with a traditional SLR, the lenses are interchangeable, allowing you to shoot from macro to extreme super telephoto. The lens shown here is typical of a 'kit' lens that you get when you buy a digital SLR (you can usually buy the camera body separately if you already own compatible lenses). Although described as an 18–55mm lens, because the camera's sensor is around 2/3 the size of a 35mm film frame these figures are slightly misleading. For most digital SLRs, multiplying the focal length of the lens by 1.6 will give you a more accurate range – in this case the 18–55mm lens would behave as a 28–88mm lens, which makes much more sense for general purposes. It's the equivalent of a 3× lens with a slight bias towards the wide-angle end.

On/Off switch [2] See Compact camera controls (pp.28-9)

Exposure compensation button [3] See Compact camera controls

Red-eye reduction light [4] See Compact camera controls

Self-timer [5] *See Compact camera controls*

Hot-shoe [6] *See Prosumer camera controls (pp.30-3)*

Mode Selector dial [7] *See Prosumer camera controls*

Pop-up internal flash [8] *See Prosumer camera controls*

Auto/Manual focus switch [9] *Modern SLR lenses are designed to work in tandem with the camera's autofocus system. However, if you want to control depth of field (pick which elements of a photo are in or out of focus) then you need to be able to focus the lens manually.*

Information LCD display [10] *The information shown here will vary depending on the camera, but usually it provides information on battery status, shutter speed, aperture, shots remaining, file format and size, metering mode, and an exposure/flash compensation warning.*

Viewfinder [11] *Digital SLRs provide a real-time optical view. Light from the scene enters the lens and is diverted via a mirror to the viewfinder, so what you are seeing through the viewfinder is exactly what the sensor will capture when the shutter release is pressed. With no electronics involved there is a negligible time delay between pressing the shutter release and the camera taking the photo – a significant benefit of all SLRs.*

LCD screen [12] *On a digital SLR, the LCD screen will not provide a preview of the image before taking a photo. Instead, it is used to assess images afterwards, and provide information on the camera's settings.*

Command dial [13] *When used in conjunction with other setting selectors, the command dial lets you change settings such as ISO, White Balance, shooting mode, metering mode, and so on. It will also allow you to change the shutter/aperture exposure combination when the camera is in Program mode.*

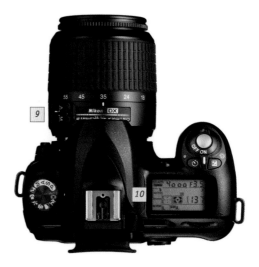

Auto Exposure/Auto Focus Lock button [14] *Using this button allows you to either focus on one part of the scene and then recompose your shot while ensuring that the original subject remains in focus; or take an exposure reading from one element and recompose the photo while retaining the original exposure.*

Continuous shooting mode [15] *Sets the camera to take continuous frames. The rate may vary, and will depend on the file format (see File formats pp.34-5).*

Playback button [16] *See Compact camera controls*

Menu button [17] *See Compact camera controls.*

ISO button [18] *Used to set the camera's ISO setting.*

WB button [19] *Used to set the White Balance setting.*

Qual(ity) button [20] *Sets the file format and size.*

Del(ete) button [21] *See Compact camera controls*

Four-way control button [22] *Used with other setting controls to adjust camera settings and functions.*

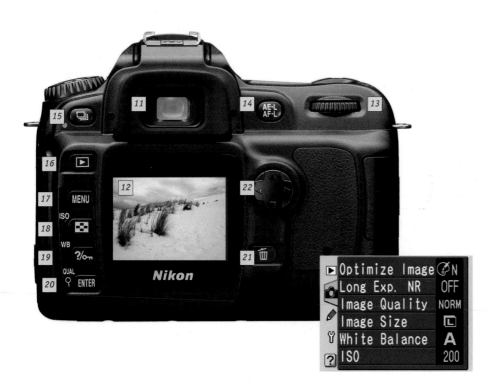

File formats

Even compact digital cameras now feature sensors with eight million pixels – and these figures are bound to get higher. The price of such high-resolution sensors is the large file sizes they produce; while high-capacity memory cards are becoming less expensive, storage space is still at a premium. This makes understanding how a digital camera compresses files so that more images fit on a storage card important.

In its raw state, the data in an 8-megapixel digital image would make for a huge file – over 22MB in size – meaning only 22 images would squeeze onto a good-sized 512MB memory card. As a result, digital images are usually compressed, so that more will fit onto a given storage device.

By far and away the most common compressed file format is the JPEG (Joint Photographic Experts Group) – pronounced 'jay-peg'. Almost all digital cameras now produce JPEG files, and this format is compatible with all image-editing software, file browsers and viewers.

Known as a 'lossy' file format because information is discarded by the compression

With minimum compression (i.e. with quality set to Maximum or Fine) this particular file is about a sixth the size of an equivalent uncompressed file. The image has hardly degraded at all and stands up to very close scrutiny.

method, JPEG files can be compressed by a factor of between 10 and 20 times the original size, offering plenty of scope for saving storage space. Unsurprisingly, the more a JPEG file is compressed the more the image quality is degraded, so as long as space on your storage card is not an overriding issue, set the camera to shoot at the finest JPEG setting.

Uncompressed formats

There are two commonly known uncompressed formats involved in digital imaging – TIFF and Raw. Few digital cameras now produce TIFF files, although the format is still widely recognized by image-editing software and file browsers. It is now more commonly used in magazine and book production, where the ability to compress the file slightly using 'lossless' compression methods has made it the preferred choice.

Today, the most popular uncompressed format is known as Raw. So called because the file is actually made up of 'raw' data, a Raw file is one in which the camera has not performed any processing on the image at all. One of the major benefits of Raw files is that they can support 16-bit colour information for each R, G and B channel. Although this will later have to be converted to 8-bit colour for printing, the extra information allows for more tonal detail and for you to make more dramatic colour or contrast corrections without adverse effects to the image as a whole. The disadvantage is that your image cannot usually be printed directly; Raw files need to be edited and saved to another format beforehand (See Using Camera Raw, pp.46-7).

TIP

If you intend to undertake a lot of post-production work on a particular JPEG image, which is likely to involve opening and closing the file between image-editing sessions, save the file in an uncompressed format before you finish the first session. Why? Well, as you open and save a JPEG file, the image is re-compressed and so the quality will degrade slightly each and every time.

With medium compression (i.e. with quality set to Medium or Standard) the file is approximately 10 times smaller than an uncompressed file. However, you have to look extremely closely to see that the image has started to degrade slightly. The fact that the image is still perfectly acceptable pays testament to how well the compression works.

With maximum compression (i.e. with quality set to Minimum or Basic) the file size is around 20 times smaller than the uncompressed file, but the image has degraded quite drastically. The colours have started to assume different values and the image appears blocky. But when you consider that you're looking at an extreme close-up, this level of compression may be an acceptable trade-off against storage space.

White Balance

During the course of a day light actually changes colour, its hue or 'temperature' shifting from blue towards red or yellow according to the position of the sun. Meanwhile, artificial light sources produce their own, even more noticeable colour casts. Our eyes adjust automatically, but to ensure that a digital camera interprets varying light temperatures as neutral we need to select the correct White Balance setting.

These comparative images show the effect of deliberately choosing an inappropriate White Balance setting. The results show how dramatic these effects can be, though it is unlikely you would want to do this in real life. This shot is the result of the camera's White Balance set on Auto. The photo was taken in the late afternoon, so the very slight reddish cast is an accurate interpretation of the light.

The colour temperature of a light source is measured in degrees Kelvin. Midday light, which is considered neutral light, measures around 5,500°K, while candlelight, which appears to us as a reddish colour, has a temperature of around 2,000°K. At the other end of the spectrum, a bright blue sky has a temperature of around 10,000°K or even higher.

Compact digital cameras usually feature a number of preset White Balance settings for the most common light temperature variations, and these usually include bright sunlight, flash, cloudy daylight, shaded daylight, tungsten and fluorescent. Most will also include an Auto White Balance setting, whereby the camera assesses the overall colour temperature of the scene and decides on the most appropriate setting. Although the efficiency of this setting varies from camera to camera, in most cases leaving the camera in Auto will provide you with accurate colours. However if you discover, when reviewing your images, that a bluish or reddish colour cast is apparent, just retake the shot with one of the preset White Balance modes. Remember: if anything about an exposure worries you, it is always worth reviewing the shot before you leave the scene.

Custom White Balance

Most digital SLRs and prosumer cameras will allow you to customize the White Balance setting. To do this find an object that you know is white, such as a piece of white card. Hold this up to the

Colour temperature

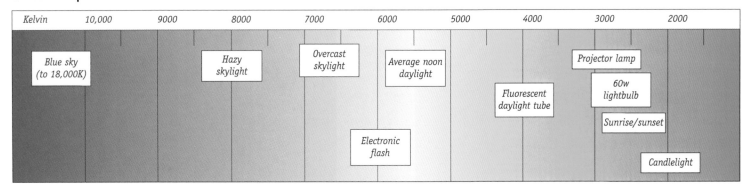

Kelvin	10,000	9000	8000	7000	6000	5000	4000	3000	2000

Blue sky (to 18,000K)

Hazy skylight

Overcast skylight

Average noon daylight

Electronic flash

Fluorescent daylight tube

Projector lamp

60w lightbulb

Sunrise/sunset

Candlelight

camera, select the Custom setting and take a photo of the white card, making sure it fills the entire frame. The camera will then set the correct White Balance for the specific lighting conditions.

White Balance and Raw

As discussed earlier, if your camera allows you to shoot Raw you should use this file format if you want to capture the most information from the scene. However, you need to remember that when shooting Raw the camera will not apply any processing at all to the image – and this includes White Balance settings, which are ignored completely. You may find, therefore, that shooting in the Raw format will result in blue or red colour casts which will need to be corrected using image-editing software later (see Fixing colour casts, pp.58-9). These can also be fixed in Raw conversion (see Using Camera Raw, pp.46-7).

Different sources of light have varying temperatures, measured in degrees Kelvin. The chart shows the light temperatures of the most common sources.

With the White Balance set to Cloudy the image has become noticeably redder. This is because cloudy daylight is slightly warmer (therefore bluer) than cloud-free daylight (which is white). To compensate for the expected bluer light the camera has produced a redder image.

Because shaded daylight is even warmer (bluer) than cloudy light, with the White Balance set on Shade the camera has compensated even further and produced an image that has an even stronger red colour cast than the cloudy image.

Fluorescent bulbs come in a variety of colour temperatures, making this light harder to balance. This camera sets the White Balance for fluorescent at 3,800°K, which is cooler (so redder) than daylight. With the camera's White Balance set on Fluorescent, therefore, the image has taken on a blue cast.

Tungsten light, such as that produced by a standard 60-watt light bulb, is even cooler than some fluorescent lights. Hence the camera with a tungsten setting has produced a very blue image.

Digital sensitivity

Digital cameras offer many advantages when it comes to coping with a variety of lighting conditions. Being able to adjust a digital camera's sensor so that it is more or less receptive to light gives the digital photographer greater flexibility – particularly in low-light situations. However, there is a price to pay if the sensitivity is turned up too much.

Sensitivity settings on digital cameras are measured in ISO ratings — the same measure that is used for different types of film. The higher the ISO number the more sensitive the sensor (or film) is to light. The advantage with digital cameras over conventional cameras, however, is that with a digital camera you can alter the ISO setting for each shot, whereas with film cameras the entire roll of film has to be replaced in order to change the ISO rating.

Almost all digital cameras feature a range of ISO settings, usually from 50 or 100 to 400 or 800 for most compact cameras, but going as high as 1600 or even 3200 for certain models of digital SLRs.

Why change the setting?

What, then, are the advantages of being able to adjust the camera's ISO setting? The answer is that changing the ISO setting affects the exposure time. Because a high ISO setting renders the sensor more sensitive to light, less time is needed for the sensor to capture the image. In other words, the higher the sensitivity, the faster the camera's shutter speed can be set to achieve the correct exposure. In low-light conditions this can prove extremely useful for two reasons.

First, imagine the subject of a photo is an evening scene. A low ISO setting of either 50

These two images were shot under the same lighting conditions. The bottom image was taken hand-held with an ISO setting of 800 to ensure a sufficiently fast shutter speed to avoid camera shake. For the top image the setting was reduced to ISO 200, thereby increasing the length of exposure, and the camera was placed on a solid surface and the self-timer used. Both are acceptable when viewed at full size (which pays tribute to the large image sensors used in modern digital SLRs); however, the proportionate inset details, which show similarly lit sections of the images, reveal the image degradation caused by the higher ISO setting.

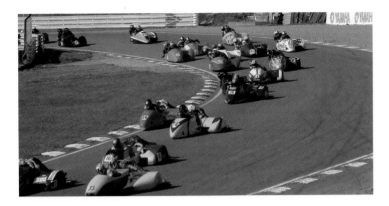

Even in good lighting conditions, such as this sunny day at Brands Hatch racing circuit, it may be necessary to increase the ISO setting to ensure the shutter speed is fast enough to freeze the action.

or 100 would require a slow shutter speed, for example 1/16 sec, to capture the scene at the correct exposure. At this slow speed, and without a tripod or something on which to steady the camera, simply taking the photo would almost certainly cause the camera to shake, resulting in a blurred image. If you choose a higher ISO setting of 400, however, the shutter speed would increase to 1/125 sec – fast enough to avoid camera shake even if the camera was hand-held.

Second, if you're trying to capture fast-moving action – even in daylight – it may be necessary to increase the ISO setting to allow for a really fast shutter speed of 1/1000 sec or more in order to freeze the action.

With a well-lit and relatively slow moving subject, always use the lowest ISO setting. The inset detail shows almost negligible noise.

The disadvantages

So, with these advantages of a high ISO setting, why not just leave the setting on high? The significant drawback is that what you're actually doing is increasing (or amplifying) the signal received from the light particles (photons) as they strike the image sensor. This in turn increases the background electronic 'noise' that is present in all electrical systems. This 'noise' usually manifests itself as unwanted coloured speckles. For example, in a clear blue sky you may find speckles of pinks, reds and greens randomly dotted around. And remember, the smaller the image sensor in the camera the more exaggerated the effect.

The answer, therefore, is one of compromise: use the lowest ISO setting available that allows you to shoot with a sufficiently fast shutter speed to avoid camera shake or freeze high-speed action, while still achieving the correct exposure. This may mean having to use an ISO that will create a small amount of noise, but this is infinitely preferable to a blurry image.

Many digital cameras have preset modes (such as for landscape, portrait or action photography) that will automatically select what it thinks are the optimum combination of ISO, shutter speed and aperture for the type of photo you're taking. However these modes are not infallible, so it's good to be able to override them and set the camera manually should you need to.

Understanding histograms

One of the significant benefits of digital photography is the ability to immediately review your images seconds after taking them. However, assessing the exposure of an image on a small LCD, particularly in bright sunlight, can be difficult. To overcome this, most digital cameras can be set so that the LCD displays the image's histogram – a form of graph that will give you all the information you need about the range of tones in the image, and how successfully your camera has captured them.

Most image-editing programmes can display an image's histogram. In Photoshop Elements, for example, going to Enhance > Adjust Lighting > Levels *(Ctrl+L in Windows/Cmd+L for Mac) will bring up the* Levels *window in which you'll find the histogram. As you'll see on pp.52–3, Adjusting brightness, moving the black, white and central (gamma) points – the small triangles underneath the histogram – is a powerful and flexible way of altering an image's brightness levels.*

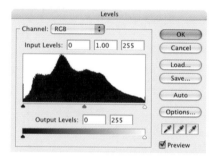

For one reason or another many people baulk at the thought of histograms – they are in fact quite simple to interpret and make assessing a photo's exposure extremely easy.

Anatomy of a histogram

A histogram, like a standard graph, has two axes. The bottom axis represents brightness values from black at the far left, through greys in the middle, to white at the far right. The vertical axis represents the number of pixels with a specific tonal value. Armed with this knowledge we can see that – in simple terms – a histogram that showed most of the pixels to the left of centre would indicate an image with a lot of dark tones or shadows, while a histogram that featured a preponderance of pixels to the right of centre would indicate an image with a lot of light tones or highlights. Potentially, the former may be underexposed, the latter overexposed.

Looking at some specific examples is the best way to learn how to read histograms.

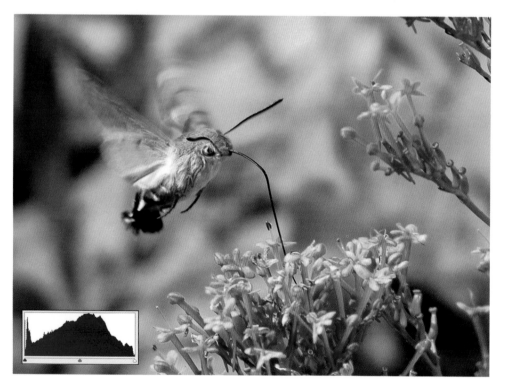

This image of a hummingbird hawkmoth feeding is evenly toned and doesn't contain any large highlight or shadow areas. This is borne out by the accompanying histogram, which shows an even spread of tone from black to white, with the majority falling near the centre of the graph.

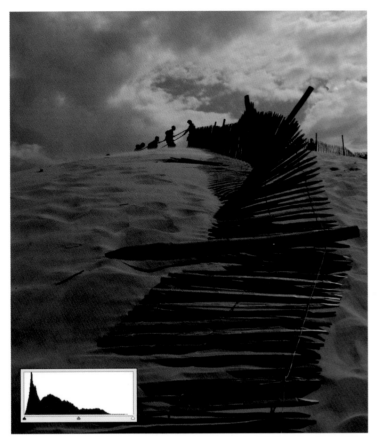

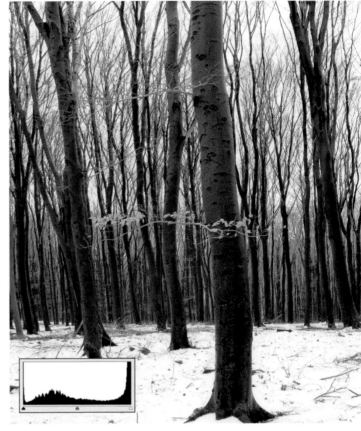

A histogram where the pixel curve is pushed to the extreme left (shadow) suggests an underexposed image, which is certainly true here. However, looking more closely, you can see that no pixels are fully pushed against the left edge – this indicates that, although underexposed, the detail in the shadows can be retrieved with editing software.

As your ability to interpret histograms becomes second nature, you'll soon find that you can predict how the histogram is likely to appear. In this shot, we know that the snow and sky will create a large area of pixels to the right edge, while the dark trees will create a grouping in the left part of the histogram, which is indeed the case.

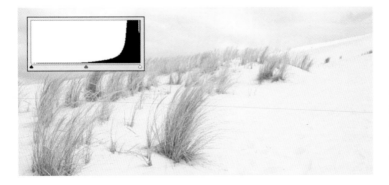

An overexposed image, such as this shot of marram grass growing in sand dunes, will produce a histogram with the pixel curve bunched up at the right-hand (highlight) edge. If the histogram shows a large number of pixels abutting the right edge then it indicates that a lot of the highlights have blown out (become completely white).

Scanning

Even if you own a digital camera, you will find a scanner a useful addition to your digital darkroom. For example, you may have old prints that you'd like to archive, reprint or make adjustments to: cropping, boosting colour, or a black and white conversion can dramatically improve an old shot. As discussed earlier, scanners are now fairly inexpensive and even small desktop models can provide excellent quality scans.

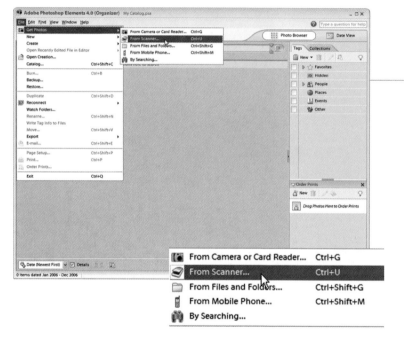

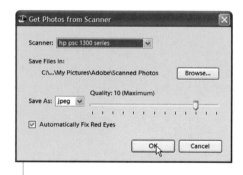

1 | *When you first open the Elements software, the Welcome screen will offer a* Get Photos from Scanner *option. Alternatively, you can scan an image from within Elements by going to* File > Get Photos > From Scanner.

2 | *Before any scanning occurs, the* Get Photos from Scanner *dialog window checks which scanner you're using, where you'd like the scanned image to be saved, what format you want the image to be saved in and – if you choose JPEG (the best format for photographs) – the quality settings. It is best to choose maximum or near-maximum quality on most occasions as you can always reduce the file size later if, for example, you're preparing an image for the Web. There's also an* Automatically Fix Red Eyes *option if you're scanning in photos of people. Once you've checked the settings, click* OK.

3 | *In the next dialog window select the option that is most appropriate. Here* Color picture *is the obvious choice. Now click* Preview.

4 | *The scanner will now make an initial preview scan. If you think the preview looks too washed out, too bright, or too dark, click the* Adjust the quality of the scanned picture *link. This will take you to the* Advanced Properties *dialog window where you can adjust the* Brightness *and* Contrast *and select the resolution you want. Here I have selected 300 ppi, which is really the minimum setting if you want to archive the image or print it at the same size as the original. If you want to make a bigger print or do a lot of work on the image, it is wise to select an even higher resolution (say 600 ppi). Clicking* OK *will take you back to the preview scan.*

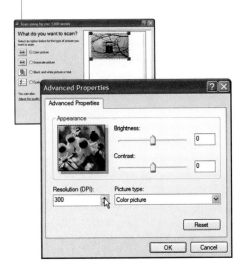

5 | *In the preview scan window click* Scan *and the scanner will now complete the scanning.*

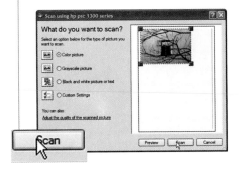

6 | *Once the scanning is complete, the image will appear in the* Organizer *window, and you can open the file and edit the image. Photoshop Elements helps here, in that it contains many tools that can polish the often slightly rough initial scan. Here I have run a small amount of the* Dust and Scratches *filter, which helps to fix any small blemishes present in the original print.*

Basic image editing

Using Camera Raw

If your camera supports the Camera Raw file format, you will quickly discover that there are many advantages to using it. Often referred to as a digital negative, a Camera Raw file does not undergo any of the in-camera processing, such as compression, White Balance adjustment and sharpening, which are applied to other formats such as JPEGs or TIFFs before they are written to the storage card.

This image shows the screen that you are presented with when using Photoshop's Camera Raw conversion software. Available to you are adjustments to White Balance, shadows, exposure and much, much more. Processing this particular image in a Raw conversion programme will give you the best chance of extracting as much detail as possible from the shadow areas without affecting the highlight areas.

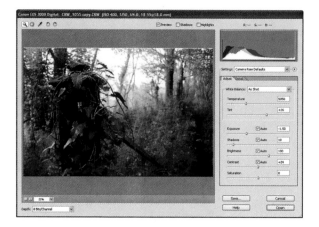
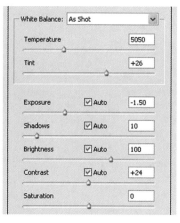

So what exactly is a Raw file? Unlike JPEG or TIFF, which in the case of the former is an acronym for the body of people responsible for the format's development, and in the latter a rough description of the format, Raw means exactly that – raw. In other words, when shooting in Raw, the image data captured by the sensor remains free of any processing. In fact, Raw is not even an image format as such – every manufacturer has its own proprietary implementation (for Nikon cameras the Raw file format is known as NEF).

One of the main in-camera interpolation processes applied to JPEGs and TIFFs is the conversion of the 12-bit colour information captured by each sensor into a combined RGB 24-bit JPEG or TIFF file, thereby discarding a lot of colour information and potentially resulting in loss of detail. Furthermore the in-camera

processing involves the creation of three 8-bit/channel files, which take up more space than a single 12-bit Raw channel – which is the raw data from the CCD before the colours are interpolated (see The camera's sensor, pp.14-15). This is why, despite having less colour information, a TIFF file is larger than a Raw file.

Working with Raw

To access Raw files you need to use the conversion software that is supplied with your camera or a third-party programme such as Photoshop, Photoshop Elements or Bibble (to name just three). Once you have opened the Raw file in your conversion software the fun really begins. What can be achieved varies slightly depending on the software, but generally it will allow you to adjust

exposure, reset the White Balance, sharpen, make highlight and shadow adjustments and even apply lens correction to fix chromatic aberration or pin cushioning. And all these adjustments can be made without degrading the image. Ultimately you will be able to squeeze image information from the Raw file that might well have been lost with a JPEG or TIFF.

Once you're happy with the corrections you've applied in the Raw converter, the file can be saved as a JPEG or TIFF and further work can take place in your editing software. While you can ensure correct contrast or remove colour casts during Raw conversion, you will not be able to remove a telegraph pole from a person's head.

Raw or JPEG?

So with all the clear image-quality benefits of shooting and processing Raw files, shouldn't we just shoot Raw all the time? Well that depends on the type of photography you undertake. As explained, you are unlikely to get a printable image from an unprocessed Raw file. So if speed

of workflow is important then you're better off shooting JPEGs. Similarly, if you're taking photos to record a family holiday or celebration – and these are unlikely to be enlarged as fine prints later – then JPEG is perfectly adequate. In fact, many photographers believe that it is almost impossible to distinguish between a Raw image and a JPEG image. This may well be true if the photograph has been shot in conditions where the camera's sensor has coped well with the difference between the highlights and shadows (the dynamic range) in the scene. If, however, the dynamic range is so wide that the sensor will have problems resolving both highlight and shadow, then shooting in Raw will give you the best chance at bringing out the subtle details in these areas later.

Many digital SLRs now offer the option of shooting JPEG + Raw. This means that if you need to process an image quickly you can use the JPEG version, but you also have the option of refining the image-quality by processing the Raw file. Although this is the best of both worlds, you'll find your storage space is used up very quickly.

Some digital cameras are capable of taking both a JPEG and Raw file simultaneously. The purpose of this is so that if you need to have useable images instantly you have the JPEG, which has been processed by the camera's software, while the Raw file, which has more information, can be processed using image-editing software at a later date. These two images show how an unprocessed Raw file (right) appears initially to have less going for it. That is because the JPEG (left) has been sharpened, had its colours boosted and had some tonal corrections made by the processing hardware in the camera.

Cropping

It is surprising how something as simple as cropping (removing part of the image area) can have such a powerful impact on a photograph, and it takes just seconds to do. Don't be afraid to experiment – you will be amazed by the range of effects that various crops will have on your image.

1 | *Not by any stretch of the imagination a work of art, but this photograph of two horses has some nice lighting. To help improve the composition let's crop out some of the dead image area to the right and top of the photograph.*

2 | *Go to the Toolbox and select the Crop tool (C). Move the cursor over to the image area and you'll see that the cursor has changed into a square formed by two 'L' shapes. Go to the point on the image at which you want to start, click the mouse, and drag over the area required. The area selected is defined by a square of dotted lines.*

3 | *Once you have made a rough selection, release the mouse and the image area outside the crop will darken. This is meant to help you visualize how the cropped image will look.*

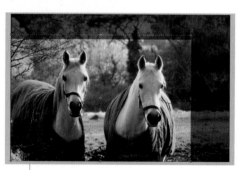

4 | *If you wish to adjust the crop simply move to one of the squares found at each of the four corners of the bounding box – the area within the dotted lines – and halfway along each edge. You will notice the cursor turn into a double-ended arrow indicating you can click and drag to adjust the crop. If the cursor turns into a curved double-ended arrow, you can rotate the cropped area at this point.*

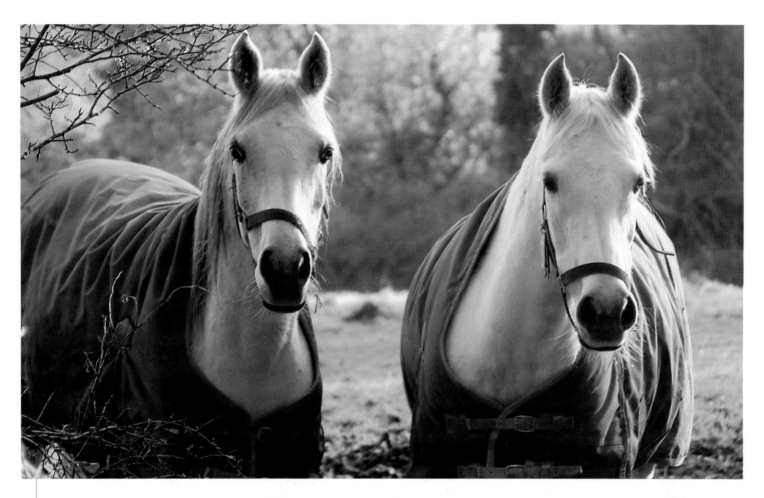

5 | *When you are happy with the crop click the commit tick icon in the* Tool Options *bar (or double-click within the crop area) to perform the crop. And remember: if the result is not what you were expecting hit Ctrl+Z (Windows)/Cmd+Z (Mac) to* Undo *or go to the* Undo History *palette and click on the step before the crop. Well, it is still not a work of art, but at least more attention is now focused on the horses' heads.*

TIP

One thing to bear in mind when cropping is that you are in effect reducing the size of your image. If your original image is 20cm × 15cm at 300ppi and you crop out the left half of the image, you will not then be able to make a print of the cropped image 20cm wide. If you tried to you would have to print at a resolution of 150ppi, which may be too low to make a good-quality print.

6 | *A useful feature of some image-editing software's* Crop *tool, including the one in Photoshop Elements, is that you can set a predetermined crop size in the* Tool Options *bar. Simply enter the dimensions of the crop you want (here I've entered 13cm × 13cm). Now when you crop the image you'll find you're restricted to those dimensions.*

Rotating

Despite our best efforts, there will be times when, having opened an image on screen, we realize it isn't straight. Either the horizon is tilted or elements that should be vertical, such as the side of a building, are leaning to the left or right. Rotating an image so that it looks straight is quick and easy, and an essential exercise before you embark on any further image editing.

1 *This shot was deliberately taken at an angle in the hope that a slight sense of drama would be created. The scene, however, is simply too light-hearted, so straightening it turns the image into a simple yet pleasing outdoor portrait.*

2 *Before trying to straighten the image, go to View > Grid. This places a greyscale grid over the whole image, giving you something to refer to when assessing how straight the image is once the rotation is complete.*

3 *Now go to Image > Rotate > Straighten Image, and Elements will assess the image and attempt to straighten it automatically. As shown here, Elements has done a pretty good job; however, if you use the grid or drag a ruler down from the top of the screen (go to View > Rulers to make them visible), you will notice that the image still needs to turn anticlockwise slightly before it is perfectly straight.*

4 *Go to Image > Transform > Free Transform (Ctrl+T for Windows/ Cmd+T for Mac). Just click OK if the warning shown above appears. Move the cursor to one of the corners of the image, and it becomes a curved line with an arrow at both ends. Move the cursor in the direction you want to rotate the image – here, anticlockwise. When finished, click the confirm tick in the Tool Options bar.*

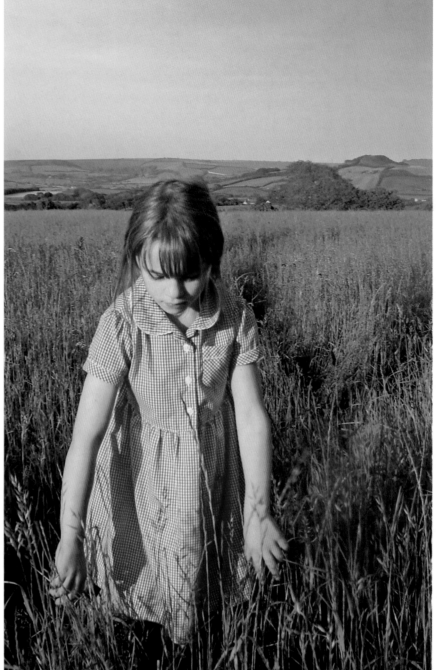

5 Now that the horizon is perfectly straight, the next step is to crop the image so that the edges are straight. Because the adjustment was quite severe in this example, quite a lot of the image has to be cropped. Select the Crop tool (C) from the Toolbox and select as much of the area as possible without going outside the edges.

6 The final image shows a perfectly straight horizon. Naturally I could have used the Free Transform command right from the start, but it is often worth trying the automated tools – they are designed to save you time and effort. Once the image is perfectly straight go to File > Save (Ctrl+S for Windows/Cmd+S for Mac).

Adjusting brightness

Although digital cameras are now pretty good at exposing images correctly, there will still be times when you will want to adjust the brightness of your images. Even the best auto-exposure systems make mistakes, and manual controls always involve a risk of user error. While Photoshop Elements has several tools – including some in the Quick Fix palette – to handle these adjustments, its most powerful is called Levels.

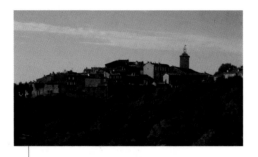

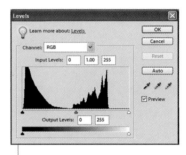

1 | To fix a poorly exposed image, such as this underexposed example, begin by going to Enhance > Adjust Lighting > Levels (Ctrl/Cmd+L). This will bring up the Levels dialog box, dominated by a histogram like those we discussed earlier (see pp.40-41).

2 | As we said, the histogram is a diagrammatic representation of the image's tonal values, running from the shadows on the left to the highlights on the right. Here we can see that the image is badly underexposed by the lack of any information in the right side of the histogram. Tick the Preview tick box so that you can see the effects of your adjustments update in real time.

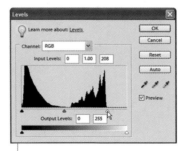

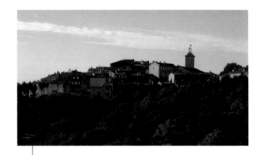

3 | To correct an underexposed image, the first thing is to slide the right-hand slider (the white point) to the left so that it sits under the edge of the last 'peak' in the right-hand section of the histogram.

4 | Moving the white point slider has improved the image a little, but although we now have a complete range of tones across the image it still appears too dark.

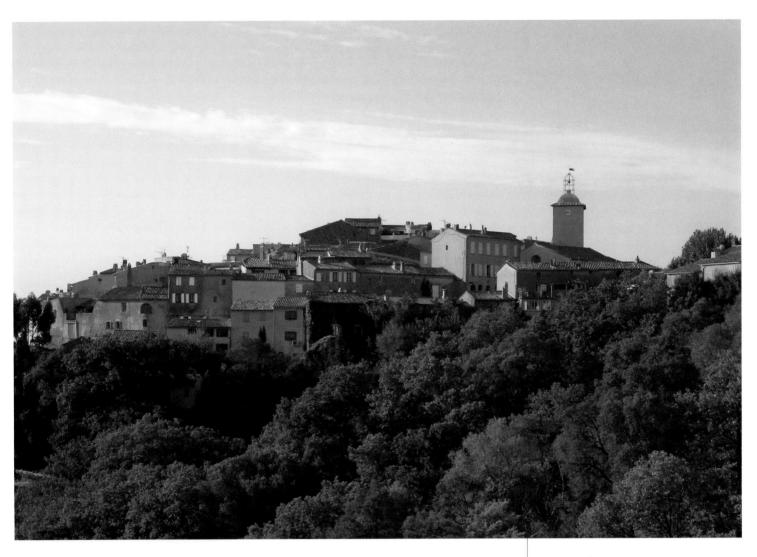

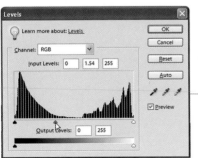

5 To lighten the image still further, we need to experiment with the central slider (sometimes referred to as the midtone or grey point). This effectively increases or decreases the brightness of the midtones. In this example we want to increase their brightness, so move the slider to the left.

6 With the Preview button ticked it is easy to see the effect that this adjustment has had. When you're happy with the image correction, click Save (Ctrl/Cmd+S). Of course, you can also use Levels to correct overexposed images. But this time, you will be moving the left-hand (black point) and midtone sliders to the right.

Boosting contrast

As shown in the previous project, Photoshop Elements' Levels command is a good way of correcting an image's brightness – Levels is a versatile tool, and can be used for most brightness and tonal adjustments. As this example reveals, it is a particularly useful feature when we want to improve contrast in an image.

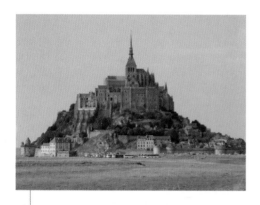

1 | *This image of the iconic landmark of Mont St. Michel in northern France is well composed and nicely focused, but it lacks real punch. In fact, it appears a little washed out. This is easy to fix.*

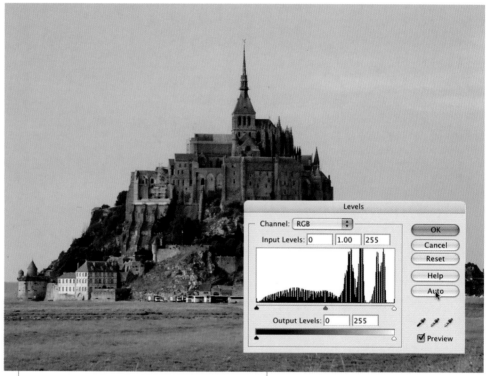

2 | *Let's begin by bringing up the Levels dialog window again. Go to Enhance > Adjust Lighting > Levels (or use the Ctrl/Cmd+L keyboard shortcut). The histogram in the Levels window reveals why the image appears so washed out – there are no pixels at either the left-hand (black) or right-hand (white) ends. What this tells us is that no pixels are either pure black or pure white, so we have an image made up only of midtones. This is typical of a low-contrast shot.*

3 | *To boost the contrast of the image, let's begin by trying the Auto command in the Levels dialog window. This sometimes works, but while the contrast of the image has definitely improved, the Auto command has introduced a slightly blue cast. To return to the original image, click Reset in the Levels dialog window.*

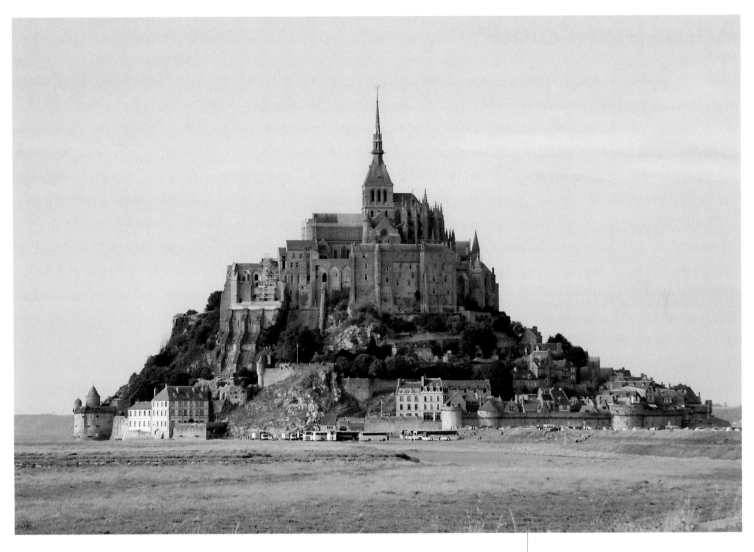

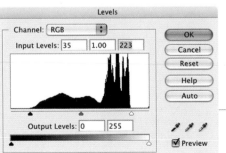

4 | *This time round we will attempt to improve the contrast manually. Return to the Levels window and move both the black and white points, so that the black point sits under the start of the slope of the first peak in the histogram on the left, and the right point sits under the end of the very last slope on the right.*

5 | *Moving the black and white point sliders has effectively introduced pure black and pure white pixels. The image now has a complete tonal range running all the way from black to white, and the contrast is therefore much improved.*

Adjusting colour

There are a variety of reasons why you may want to adjust the colour in your images – you may, for example, want to boost the colour, fix an ugly looking colour cast caused by an incorrect White Balance setting, or simply try variations of colour to create a specific mood. All these are possible and quite easy to achieve in most image-editing programmes.

Boosting colour

There may be occasions when, having taken a photo of a glorious summer scene, you open the image on your computer only to be disappointed with the results. In a photo taken on a bright summer's day, for example, the colours can appear washed out. This is most noticeable during midday when the sun is at its highest and the colour temperature is a neutral white. However, with a few quick corrections you can bring back some of that lost colour.

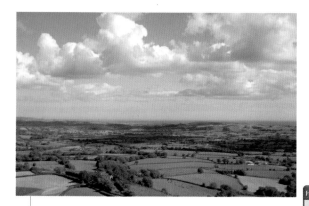

1 *Having climbed to the top of a steep hill to take this photo, carefully ensuring the exposure was correct and using a tripod to ensure I got a really sharp image, I was quite disappointed by how flat this photograph looked.*

2 *To bring back some of the missing colour go to Enhance > Adjust Color > Adjust Hue/Saturation to bring up the* Hue/Saturation *dialog window. The control that we are most interested in here is the* Saturation *slider. Slowly move the slider to the right to boost the colours in the image.*

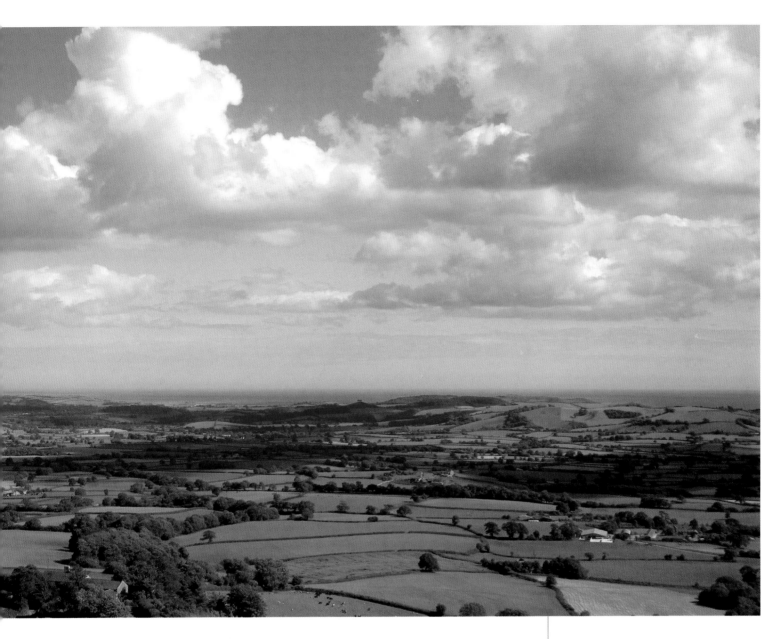

3 *To boost the sky, return to the Hue/Saturation*
dialog and click on the arrow next to Master.
A pull-down menu will appear. First select Blue
and again gently increase the Saturation slider,
remembering all the time to check how the
adjustment is looking. Now repeat the same
exercise, this time selecting Cyan.

4 *The final result is much more how I envisaged*
the scene in my mind's eye. The sky is now a
much deeper blue and the fields are luscious
green – but with careful control the image still
appears perfectly natural.

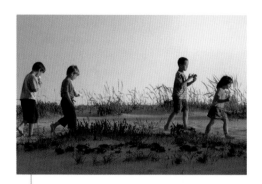

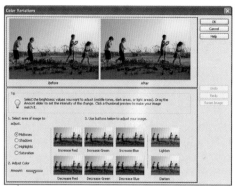

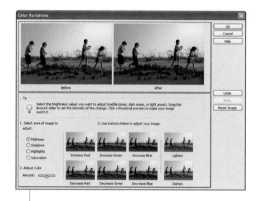

1 | Taken at the end of the day, I was expecting, and wanted, this image to have a slight pink cast to it. However, looking more closely at the sand I felt that the pink cast was too dominant.

2 | Photoshop Elements has a very quick fix for colour casts: Enhance > Auto Color Correction. *This tool is often very good, but on this particular occasion it over corrected and removed all the pleasant rosy colour. In this case, the next step is to try the* Color Variations *tool:* Enhance > Adjust Color > Color Variations. *This is an extremely versatile yet powerful tool that has the added benefit of giving you a preview before you commit to any changes.*

3 | To reduce the red colour cast, all I need to do is click on the Decrease Red *window once or twice. The preview shows the effect of the adjustment. The image has lost its overly pink cast, some of the original blue sky has returned, and the sand is now a more realistic-looking colour.*

Fixing colour casts

As discussed earlier (see White Balance, pp.36-7) modern digital cameras are pretty good at compensating for the ambient colour temperature when shooting in various lighting conditions. However, every now and again the camera can get it wrong. Let's look at how to fix an unpleasant looking colour cast.

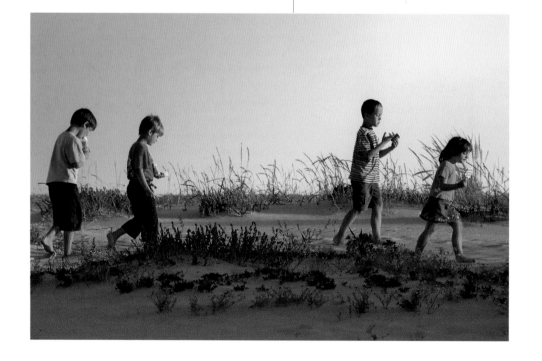

Creative colour correction

There are often many occasions when discarding naturalistic colour can create a much more powerful image – black and white images automatically spring to mind. However, Elements' colour control capabilities open up some more additional creative routes. For example, other hues, such as sepia, can be particularly effective if the image suits a vintage treatment, and with no mess, expense or waste the digital darkroom is perfect for this kind of experimentation.

1 | Natural-looking colours are not particularly important in this shot of an old village house in Hungary. In fact, to add atmosphere let's experiment with some different colours.

2 | To start, return to the Hue/Saturation dialog that we used earlier to boost colours. This time, before touching any of the sliders, click the Colorize button at the bottom right of the window. Instantly Elements applies a default sepia tone to the image. This is quite an effective adjustment, but let's try some other colours.

3 | Simply by moving the Hue slider up and down, a whole range of colour effects can easily be applied. It is simply a matter of experimenting until you find a shade that you feel compliments the image.

Dodging and burning

Dodging and burning are both traditional darkroom techniques that were used to lighten (dodge) or darken (burn) specific areas of a photograph. Luckily, in the digital darkroom we don't need to use card to mask off areas of the image during exposure; we can brush on our adjustments and, if necessary, use the Undo command should our dodging or burning go beyond what we intended.

TIP

With so many adjustments you make in image-editing software it is all too easy to go over the top. Remember: for a natural-looking image, less is usually more.

1 | *Taken in the Jewish Cemetery in Prague, I felt this image could be made even more effective if I dodged the central white headstone so that it appeared even brighter.*

2 | *Go to the Toolbar and select the Dodge tool (O) – it is grouped together with the Burn and Sponge tools.*

3 | *Go to the Tool Options bar and reduce the Opacity to around 30% and select a medium-sized, soft-edged brush. This gives a more subtle, controllable result. Finally, as the tombstone we're going to lighten is fairly uniform in tone set the Range to Midtones. Now, brush carefully over the stone, dropping the Opacity further if you start losing detail.*

If at any time applying the Dodge tool creates an unpleasant change in colour in the object you're dodging, try changing the Range to Shadows or Highlights. Here, I've tried to keep the dodging down to a minimum so that the result looks natural. | 4

1 | Parts of the very light coat of the dog on the right in this image are overexposed, almost to the point where the detail is lost.

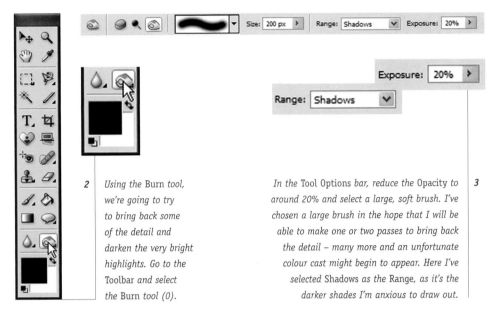

2 | Using the Burn tool, we're going to try to bring back some of the detail and darken the very bright highlights. Go to the Toolbar and select the Burn tool (0).

In the Tool Options bar, reduce the Opacity to around 20% and select a large, soft brush. I've chosen a large brush in the hope that I will be able to make one or two passes to bring back the detail – many more and an unfortunate colour cast might begin to appear. Here I've selected Shadows as the Range, as it's the darker shades I'm anxious to draw out. | 3

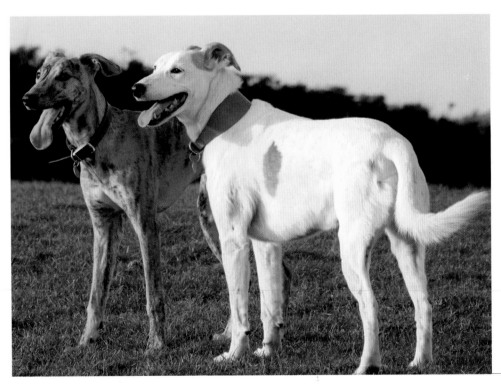

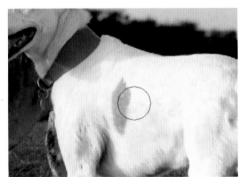

4 | Brush over the area of the dog's coat you are trying to darken. With both the Dodge and the Burn tool there can be a slight delay before the tool takes effect, so pause briefly after each stroke to assess the result.

5 | The Burn tool has done quite a good job of bringing out some detail from the fur, and the brown spot has become noticeably darker.

Sharpening

Much will depend on your digital camera (or scanner) and the settings used, but some images, once downloaded and viewed on your monitor, can appear 'soft'. These images are not necessarily out of focus – the softness can simply mean that the camera's internal processing has deliberately not attempted to sharpen the image automatically, giving you more control over how much sharpening to apply later in image editing.

1 | *This image, although not out of focus, is soft and could do with being a little sharper. While Photoshop Elements has several sharpening commands, the most effective is the odd-sounding Unsharp Mask. This name is derived from the old darkroom technique of combining a blurred positive image with the original negative – this accentuated the edges of the negative.*

2 | *Go to* Filter > Sharpen > Unsharp Mask. *The* Unsharp Mask *dialog comprises a cropped preview of the main image and three sliders. The second,* Radius, *is the Unsharp Mask powerhouse. This identifies the image's edges and makes one side lighter and the other darker. The third,* Threshold, *dictates how many pixels from the edges outwards are affected. The first,* Amount, *is fairly self-explanatory.*

3 | *Try* Amount: *200%;* Radius: *5;* Threshold: *0. Straight away, you can see that the image has been oversharpened. The biggest give-aways are the ugly looking haloes that appear around elements of the image – check the edges of the trees and near the chimney pots where you can see the blue sky.*

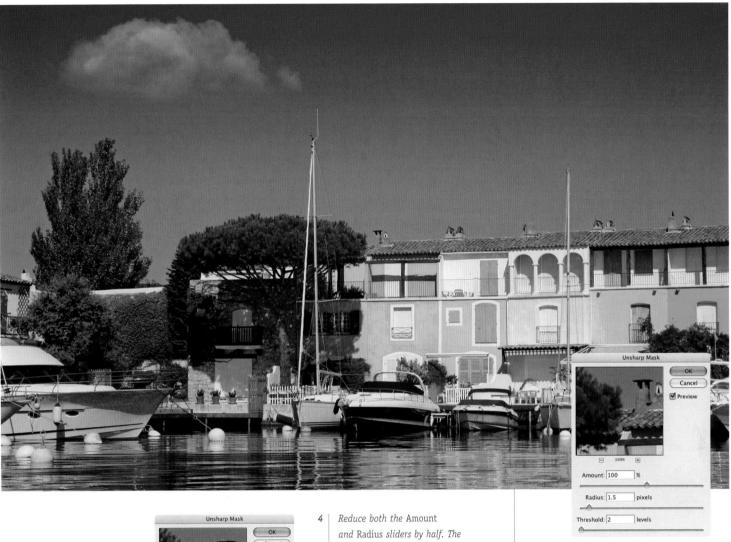

4 *Reduce both the Amount and Radius sliders by half. The sharpening effect is drastically reduced. At this point, by clicking on and off in the Preview window (where a small hand icon will appear) you can see the sharpening effect. You can also navigate around the image by dragging the hand icon to see how different sections of the image are being affected.*

5 *With these new settings, the image is much improved. The really obvious haloes have disappeared and the picture is much sharper. This result would be fine for screen use. In my experience, images viewed onscreen always appear less sharp than when printed, so let's reduce the Radius even further, and set Threshold to 2 to restrict the number of pixels that are affected. The photograph is now ready for print.*

Removing unwanted objects

Traditionally, removing even simple objects from photographs was the work of highly skilled artists who had a good understanding of working with negative film and print media – and even then the results were often far from convincing. With a digital image, it's different. As pixels are highly mutable, it's a relatively easy task to 'clone' a suitable part of an image and 'paste' it on top of the element of the photograph you want to remove. Here we're going to look at a couple of the more popular retouching tools.

The Clone Stamp tool

Cloning over parts of an image is seriously frowned upon in professional photographic circles. In fact a number of photographers, having been caught digitally retouching their photos, have been expelled from their professional bodies.

Of course, we amateurs and enthusiasts don't run the risk of such severe punishment, but there are a number of ethical issues that we should think of before retouching a photo – if we're submitting it for a competition for example.

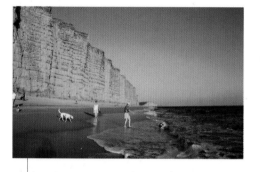

1 | *For demonstration purposes only, we're going to take a pleasant holiday scene on the south coast of England and obliterate all signs of life – including the shadow of the photographer at bottom left!*

2 | *The main tool for the job is the Clone Stamp tool (S). Select this tool from the Toolbar, then go to the Tool Options bar at the top of the screen. Select an appropriately sized soft brush and set the Opacity to 100%. We'll discuss the Aligned tick box later.*

3 | *Let's begin by removing the man in the cap and shorts. Zoom in close to the man and, holding down the Alt key (Windows) or Option key (Mac), click at a point aligning with his cap. When you depress the Alt/Option key the Clone Stamp's circle turns into a target-shape icon – this indicates that the tool is going to clone from this point.*

4 | *Now click the mouse, then move the cursor over to the man's cap and click and drag slightly. You'll see the man's cap being replaced by the section of cliff you clicked on earlier. A crosshair indicates, as you move the Clone Stamp circle to and fro over the hat, the point from which the tool is cloning. If you have Aligned checked in the Tool Options bar and don't select another cloning point the crosshair moves relative to the position where the tool was first used. If, however, Aligned is not ticked and you do not select another cloning point, the tool clones from the original point. For best results, select a new point each time you brush.*

Size: 100 px Mode: Normal Opacity: 100% ☑ Aligned

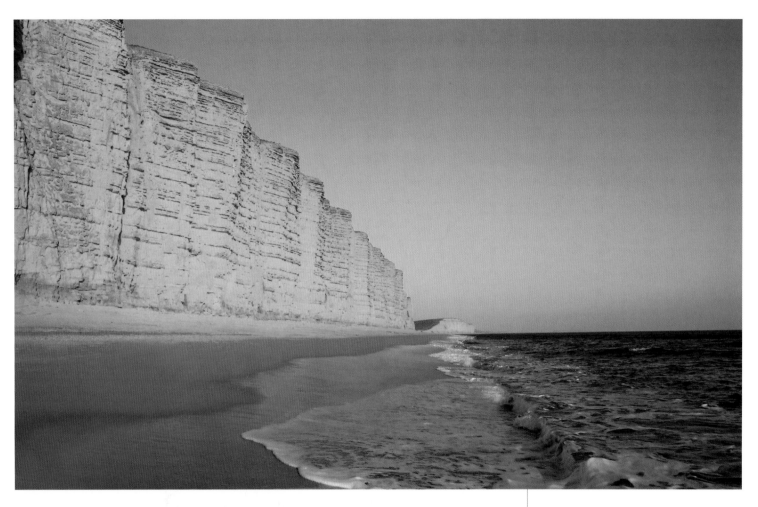

5 Let's zoom out and look at how well the cloning has worked. It's not a bad result. The secret to using the Clone Stamp tool is practice. At first you may find it difficult to master the order in which you click, release, drag and so on, but you'll soon pick it up.

6 Carry on with the unwanted elements until you get a deserted beach. For convincing cloning, it's imperative to concentrate on clearly defined edges, such as the mark left between the wet and day sand as the sea recedes. This needs to run through the man's midriff. Getting these areas right makes for a much more convincing effect.

The Spot Healing tool

Another important tool for removing unwanted objects is the Spot Healing tool. As explained earlier, the risk of dust entering the lens and settling on the sensor is perhaps the most significant drawback to digital SLRs – particularly when changing lenses frequently. This results in black spots appearing in the same place, every time, on your images. While the spots are only really noticeable in areas of flat (or flattish) colour and tone, once you've spotted them you will think you can see them everywhere.

1 | *This section of a photograph of a kite festival shows just how annoying it can be if you have dust on your camera's sensor. (It was this particular image that forced me to pluck up the courage and buy a sensor cleaning kit!)*

2 | *Luckily, there are only one or two bad spots, and if I can't go back in time and clean the sensor, the next best thing is to go to the Elements Toolbox and select the Spot Healing tool.*

3 | *Using the Spot Healing tool couldn't be easier. Simply adjust the size of the tool's circle so that it fits closely around the offending spot. Remember you can change the size of the brush quickly and easily using the '[' and ']' keys. When you are happy with the circle size simply click the mouse button and watch the spot vanish.*

4 *It took a matter of seconds to get rid of all the spots in this section of the photograph. Of course, it doesn't just work on spots caused by dust on the sensor: the Spot Healing tool also makes short work of skin blemishes, acne and moles.*

Advanced
image editing

Making selections

Once you've got to grips with the more straightforward image corrections, you're ready for some more advanced editing techniques. Many of these involve being able to isolate certain elements of an image so that adjustments can be made to those alone – or, indeed, to the rest of the image outside of a protected area. The key skill here is the ability to make selections. Conveniently Photoshop Elements groups most of its selection tools together towards the top of the Toolbox. Let's take a look at them.

Marquee tools

The two Marquee tools (Elliptical and Rectangular) are found in the same place. To select the one not shown, click and hold in the Marquee tool in the Toolbox and a pull-out menu will appear showing both options. Either can be used to select basic shapes within an image.

1 | *Here we're going to use the* Elliptical Marquee *tool to make a simple vignette of this portrait shot.*

2 | *Select the* Elliptical Marquee *tool from the* Toolbox *and draw an oval vignette shape over the boy's face, ensuring that you leave space above the head and that the oval covers the shoulders. If your placing isn't perfect, don't worry. Once the ellipse is visible, you can use the arrow keys on the keyboard to fine-tune the position.*

Feather Radius: 40 pixels

3 | *Most vignettes have a soft rather than hard edge. To achieve this go to* Select > Feather *and set a Radius of around 40 pixels. The value of the radius will depend on the resolution of your image, so you may need to increase or decrease the value accordingly.*

4 | *We want to delete the background, not the area within the ellipse, so to delete the correct portion go to* Select > Inverse *(Ctrl/Cmd+Shift+I). Hit Backspace to delete everything outside your selected area.*

5 | *Finally, crop the image to delete the unwanted white space around the vignette. Finish by saving the image. Use* File > Save As *if you don't want to overwrite the original shot.*

Magic Wand

The Magic Wand tool is another very simple tool with which to make selections. However, it isn't quite as 'magic' as the name suggests – it needs areas of high contrast to work effectively. It is at its best when selecting an obvious subject from an evenly coloured background, such as a building in front of a blue sky.

1 | *Here we're going to use the Magic Wand to select the black background from this aquarium and isolate the seahorse.*

2 | *The Magic Wand is found underneath the Marquee tools. Select the tool and then click on any part of the black background with the wand icon.*

3 | *The Magic Wand will now select all similarly coloured and toned pixels in the image – the area is identified by a dotted line (often called the 'marching ants'). You can adjust how sensitive the Magic Wand is by adjusting the Tolerance setting in the Tool Options bar. Here, as the background is uniform, the Magic Wand has selected almost the entire thing. To select small areas that weren't caught first time round, hold down the Shift key (a small '+' symbol will appear next to the wand icon) and click on any unselected areas.*

If you want the Magic Wand to deselect a specific area, hold down the Alt key (Windows)/Option key (Mac). A small '-' sign will appear next to the Wand icon. Now, click on a previously selected area and it will be removed from the selection.

4 | Once the entire background is selected, go to Select > Feather and in the resulting dialog window enter a value of 1 pixel; this helps soften the edge around the selection. Now go to Select > Inverse (Ctrl/Cmd+Shift+I) to select the seahorse rather than the background.

5 | With the seahorse selected you can do whatever you like with it. Here I've simply copied (Ctrl/Cmd+C) and pasted (Ctrl/Cmd+V) the seahorse several times and rescaled it using the bounding box. If the bounding box is not visible, click on Bounding Box in the Tool Options bar.

Lasso tools

There are three related Lasso tools – the basic Lasso, the Polygonal Lasso and the Magnetic Lasso. To access any one of them, click and hold down the Lasso tool in the Toolbox and, as with the Marquee tools, the three options will be made available. The Lasso tool is a freehand tool, and as such it is hard to control accurately. However, it can sometimes be used to select large areas of an image that do not require accurate selection. The Polygonal and Magnetic Lasso tools offer much more control.

Basic Lasso

Because it is extremely hard to make accurate selections with the Lasso tool, it is only useful if you want to select a relatively large area of a photo.

1 *This photo was taken with late afternoon sunlight which, while bringing out the rich colours of the fishing nets, has resulted in a large area of the image appearing underexposed.*

2 *To lighten the central part of the image, select the* Lasso *tool from the Toolbox and make a rough freehand selection of the offending area.*

3 | *A noticeable boundary between corrected and uncorrected areas would spoil the effect, so we need to feather the selection. Go to* Select > Feather *and use a high pixel value – here I've entered 150 pixels.*

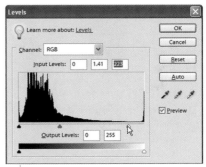

4 | *Next go to* Enhance > Adjust Lighting > Levels *(Ctrll/Cmd+L), and move both the midtone and white point sliders slightly to the left. This will brighten the underexposed portion. Click on and off the* Preview *button to view your changes. Note that, because of the large amount of feathering, the boundary between corrected and uncorrected areas is not so obvious. The final image retains the rich colours brought about by the warm light, but the previously underexposed area is now better balanced with the rest of the image.*

Polygonal Lasso

The Polygonal Lasso tool is ideal for selecting any irregular shapes,
but works best with those that feature straight edges.

1 | *Here we're going to use the* Polygonal Lasso *to select the interior of the window. This should reveal some of the detail that I know is lurking somewhere in there.*

2 | *Select the* Polygonal Lasso *from the Toolbox. Click in one corner of the window frame and then click at the opposite corner. The* Polygon Lasso *will draw a straight line between the two points. Note that straight edges are the tool's major area of expertise: you can use a lot of short lines to draw around curves, but it requires a lot of clicking and the results aren't always satisfactory.*

3 | *When you return to the start point a small circle will appear next to the tool's icon. Clicking here will show the marching ants around the selection.*

4 | *With the selection completed and feathered by 1 or 2 pixels, a simple* Levels *correction reveals some of the interior of the room.*

Magnetic Lasso

As its name suggests, the Magnetic Lasso will actually stick to the edges of the selection you're making. However, like the Magic Wand, this tool relies on there being a clear distinction in either colour or tone to identify the edge.

1 *In this example, we're going to select one specific flavour of soap and change its colour with a Hue/Saturation adjustment.*

2 *Select the Magnetic Lasso tool and choose one of the soap batches; here I've gone for the one to the top left. Click in the corner of your selected batch and without holding down the mouse button drag along the edges of the soaps. You'll see that Elements draws a line along the edge of the soaps and the wooden box. You'll also see that little boxes are placed regularly along the selection line. If at any point the selection goes wrong, hit Backspace and the tool will jump back to the previous box. When you get to a suitable point, click the mouse. This locks that section of the selection so it will not move. Continue dragging along the line and further selections will be made. When you get back to the start point, a small circle will appear. Click to finish the selection.*

3 *With the selection completed, you can now make a Hue adjustment (Ctrl/Cmd+U) and change the soaps to any colour you like.*

Creating masks

On previous pages, we looked at selecting areas that were easy to define. However, you will often want to select more complex shapes, such as the outline of a person. By far the most accurate tool for making difficult selections is Elements' Selection Brush tool. It can be used to create 'masks' – a traditional darkroom term for a sheet of red acetate that was cut to a specific shape to ensure the correct elements were affected or protected during operations. The digital version works in much the same way.

1 | Let's make a mask of this strange piece of art
I spotted in a French market. By the way, the sign
reads, 'But where's this feeding bottle?'

TIP

When you're engaged in complex tasks, the Undo History palette is your friend. If you make a mistake, you can use it to return to a point before it all went horribly wrong.

2 | *Before you select the Selection Brush tool (A) from the Toolbox, use the Zoom tool (Z) to zoom in close.*

3 | *Next select the Selection Brush tool, then – in the Tool Options bar – select a small brush size, appropriate to the resolution of your image. Here I've selected a 13 pixel brush. Leave the rest of the settings in the Tool Options bar as shown here. Now, in the close-up of the image, begin to trace carefully around the outside edge of the doll and the box. Trace the outline in small sections, so that when you go wrong you can go to Edit > Undo (Ctrl/Cmd+Z) to undo the mistake. This way, you can build up your mask bit by bit.*

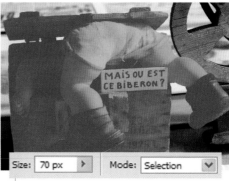

4 | *Once you're happy with the outline, return to the Tool Options bar and increase the size of the brush – here I've increased the brush size to 70 pixels.*

5 | *With the larger brush, start to fill in the mask. Remember, you can always use the '[' and ']' keys to increase and decrease the size of the brush without having to go back to the Tool Options bar.*

6 | *Once you've filled in the mask selection, go to the Tool Options bar and select Selection from the Mode pull-down menu.*

7 | *Changing to* Selection *brings up the familiar marching ants that indicate the selected area. Here I've noticed that I've gone wrong around the toe of the boot. Using the brush tool, I can push back the selection so that it sits closer to that appendage.*

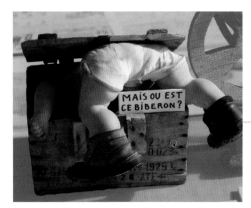

8 | *Once you're happy with the selection, return to the* Mode *menu in the* Tool Options *bar and switch back to* Mask. *Now go to* Select > Inverse *(Ctrl/Cmd+Shift+I) and you'll see that everything other than the baby in the box is now red. This indicates that the area you want to delete (i.e. the mask) is now the background.*

9 | *As always, softening the line around the selection creates a more realistic effect. Go to* Select > Feather *and set a value of around 1 pixel. Now hit* Backspace *and you'll be left with just the baby.*

The Magic Selection Brush

The Magic Selection Brush tool works in much the same way as the Magic Wand, in that like the Magic Wand the Magic Selection Brush tool works by selecting pixels of a similar colour and tone.

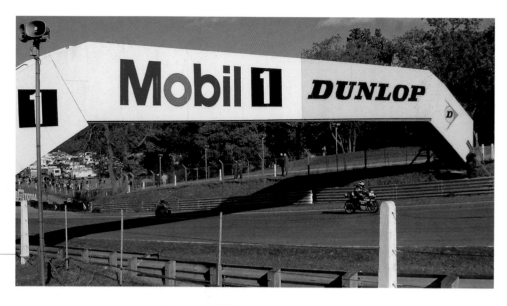

Let's try using this tool to select the bridge running over the track. **1**

2 *Select the* Magic Selection Brush *tool (F) from the* Toolbox, *and paint a line across the bridge. As the result shows, because the colour lettering on the bridge is a close match to other elements of the photograph, such as the sky, the* Magic Selection Brush *tool has selected a lot more than just the bridge.*

3 *It's possible, however, to make smaller selections and then add to them. Let's start again. Make a small stroke on the bridge, then go to the Tool Options bar and ensure that the icon with a small '+' symbol is highlighted. Return to the image and paint on another selection of the bridge.*

4 *When you add to the selection, you'll see the red strokes made by previous selections. Repeating this process will eventually result in a selection of the bridge, without the extra, unwanted elements.*

Correcting perspective

Converging verticals are a common photographic problem, particularly when shooting tall buildings from ground level. Because the camera has to be pointed upwards to ensure the entire building fits in frame, the building appears to lean backwards in the final photograph. Before image-editing, the only way to avoid this was to use an expensive lens, known as a perspective-correction or shift lens. However, with Photoshop Elements you don't need to bother: you can correct perspective at the editing stage.

TIP

As an alternative to using a grid to check converging verticals, try a ruler. Select View > Rulers and drag down from the ruler at the top.

1 | *This photograph of the Cathedral of Notre Dame in Chartres, northwest France, shows the effect of converging verticals. With a building of this height (115m/375ft) the twin spires appear to point inwards and the whole building looks as if it is leaning away from the camera.*

2 | To help assess and then straighten the verticals, go to View > Grid. *This places a greyscale grid over the image against which you can align the building's vertical elements.*

3 | Next go to Image > Transform > Perspective. *If you're working on a flat, single-layer image, as taken directly from the camera, Elements will ask you if you want to change the Background layer into one on which you can make the adjustments. You do, so click OK, then OK in the dialog that appears immediately afterwards.*

4 | To straighten the verticals, click on one of the top corner bounding box squares and drag it out – you'll see that the opposite corner moves out at the same rate. Keep dragging until the building's verticals align with the grid. Make a note of the percentage width increment; in this example the width was increased by around 139%.

5 *With straightened verticals, the result is a very squat-looking building. The Rose window is an ellipse rather than a circle, and the van in the foreground looks flat. To fix this, the Cathedral needs to be stretched vertically, and because it's such a tall building, you need to make the 'canvas' or working area bigger in order to accommodate the stretched image. Go to* Image > Resize > Canvas Size, *and in the resulting dialog box increase the image's* Height *by 50%.*

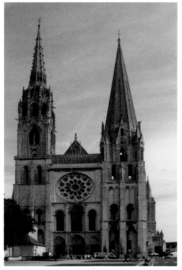

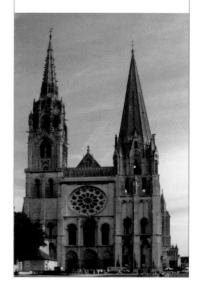

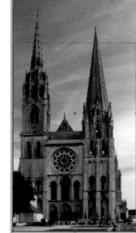

6 *Having created more room to work with, click on the* Rectangular Marquee *tool (M) in the* Toolbar *and select the existing image area. Next, go to* Image > Transform > Distort *and click the centre bounding box marker. Drag it upwards, until the* Height *in the* Tool Options *bar matches the width measurement you noted earlier (in this case 139%). Also, gauge how the building looks visually. Is the Rose window as round as it should be? Does the van have the correct proportions?*

7 | With the Cathedral now at the correct height, all that remains to be done is to crop away the unwanted canvas using the Crop tool (C). With the correction complete the image more successfully conveys the sheer enormity of the building. To finish go to File > Save *(Ctrl/Cmd+S)*.

Using layers

One of the most powerful features of many image-editing programmes, including Photoshop Elements, is the ability to arrange various image elements in layers. Sadly, for many novices layers present something of a mystery, which is a shame as they open up a more flexible and powerful way of working. So let's begin with one aspect of how layers work and what you can do with them.

The great strength of layers is that you can add elements to an individual layer, then alter their position and the opacity (or transparency) of the layer as you see fit. This opens up a whole world of creative possibilities. One of the most common uses is to combine two or more images to make one composite image.

1 | *Here we're going to combine these two images of children to make a surreal, if not slightly worrying, single image.*

2 | *First, open the image of the boy and select the* Elliptical Marquee *tool (M) from the* Toolbox. *Draw a circular selection around the boy's face. To make a perfect circle hold down the Shift key as you drag over the face. When you're happy with the selection, go to* Edit > Copy *(Ctrl/Cmd+C).*

3 | Now return to the image of the girl, and go to Edit > Paste *(Ctrl/Cmd+V)*. The boy's face will appear on the girl's photo. Using the Move *tool (V)* place the boy's face over the grapefruit in the girl's hand. Now if you click open the Layers palette – hit F7 on the keyboard if you can't see it – you'll see there are now two layers: the Background image of the girl and a new layer showing the boy's face. Click to highlight the text 'Layer 2' in the Layers palette and change it to read 'Boy's face'. With just two layers, you're unlikely to forget which is which, but giving layers meaningful names can help enormously if you have several similar-looking layers open in a document.

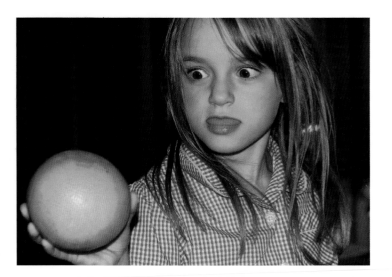

4 | Still in the Layers palette, ensure that the Boy's face layer is selected and that Show Bounding Box is ticked in the Tool Options bar. This will put a bounding box around the boy's head, and by pulling on the corner and side points you can fit the face accurately to the grapefruit.

5 | To check how well the boy's face fits the area of the fruit, click on the eye next to the face layer's thumbnail image – this turns layer visibility on and off, and will make the layer temporarily invisible. By clicking on and off the eye icon you'll be able to gauge how good the fit is.

6 | *Now we need to merge the grapefruit with the face. To do this, reduce the Opacity of the Boy's Face layer in the Layers palette – simply move the Opacity slider to the left until the grapefruit texture shows through. Doing this, I noticed that the face slightly overlaps the fruit, so I used the Eraser tool (E) to tidy up any overlap. Don't worry: the eraser tool will only affect the current layer.*

7 | *To finish, go to Layer > Flatten Image. This compresses all the layers into one (you can see this by looking at the Layers palette). It's time to save the image (Ctrl/Cmd+S).*

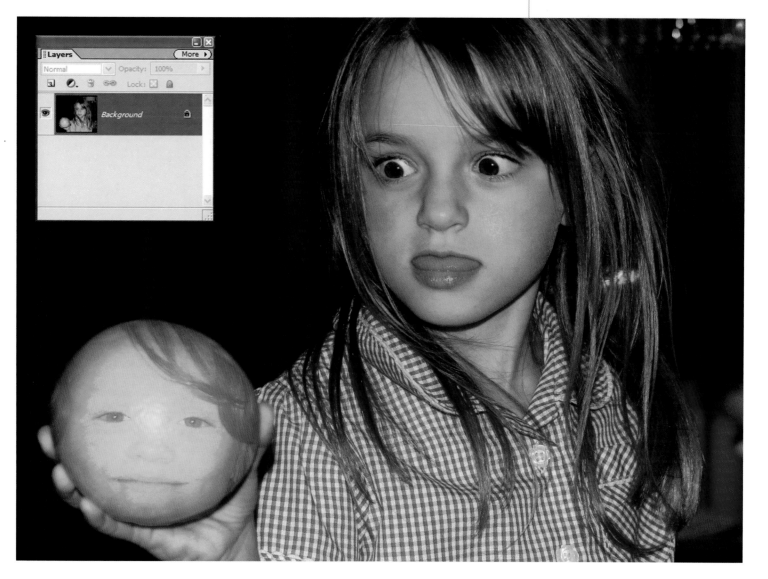

Restacking layers

Now that you've followed a basic project using two layers, it's important to understand the way in which layers can also be moved up and down the Layer stack, not to mention the effects this has.

1 | Here the image and the accompanying Layers palette show layer 1 at the top of the layer stack.

2 | Here I've dragged layer 1 to the bottom of the layer stack, resulting in layer 2 sitting at the top of the stack. To move a layer, just click and hold it down, then drag it upwards or downwards.

3 | Here, with layer 2 dragged to the bottom of the stack, layer 3 is now visible.

4 | By reducing the Opacity of layer 1 and layer 2, all three layers can be seen.

Adjustment layers

Layers aren't used just to create composite images; a specialist form, an adjustment layer is important in all areas of imaging. Although we haven't used adjustment layers in any projects so far, they prove useful in most brightness, contrast and colour fixes. In fact, you'll learn that adjustment layers are the key to a safer, more flexible working method.

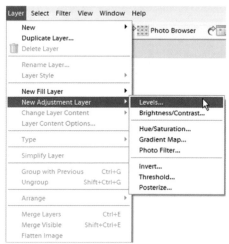

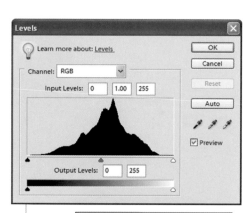

1 *Using various adjustment layers, we're going to take this drab-looking beach shot and attempt to turn it into something more dramatic.*

2 *Let's begin by making a Levels adjustment. We'll use the same Levels dialog as before, but this time the adjustment is tied in to its own separate layer. Go to Layer > New Adjustment Layer > Levels, and a dialog window will appear asking what you want to call the layer. If you're happy with Elements' suggestion of 'Levels 1' click OK.*

3 *As soon as you click OK the familiar Levels window appears. You will also notice that a new layer (Levels 1) has appeared in the Layers palette.*

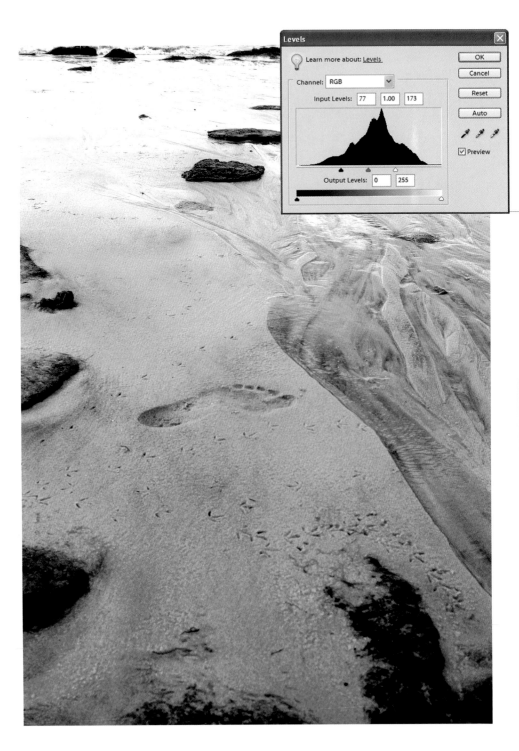

4 I'm going to make quite a radical Levels adjustment here in order to create a saturated high-key effect. To do this slide the black and white point sliders to midway between the midpoint and the end of the black and white points on the histogram. Click OK to finish.

5 Now create a Hue/Saturation adjustment layer. There is always more than one way to do a task in Photoshop, so this time click the 'Create adjustment layer' icon at the top of the Layers palette (the second icon from the left) and then choose Hue/Saturation from the menu. Just as before Elements automatically creates a new layer called 'Hue/Saturation 1'.

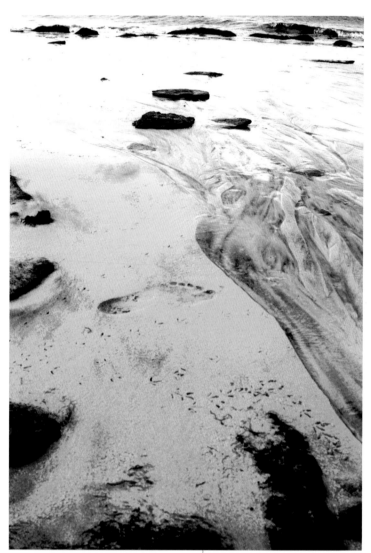

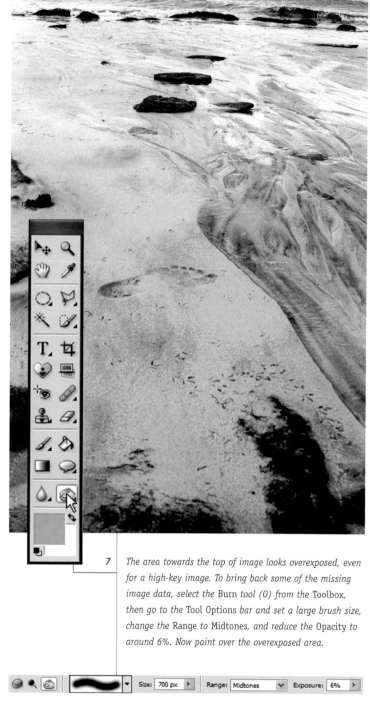

6 The new Hue/Saturation layer should pop up in the Layers palette and the Hue/Saturation dialog window will appear on your screen. Again I'm going to make quite a radical adjustment here to really saturate the colours. Drag the Saturation slider to the right until it hits the +50 mark.

7 The area towards the top of image looks overexposed, even for a high-key image. To bring back some of the missing image data, select the Burn tool (O) from the Toolbox, then go to the Tool Options bar and set a large brush size, change the Range to Midtones, and reduce the Opacity to around 6%. Now paint over the overexposed area.

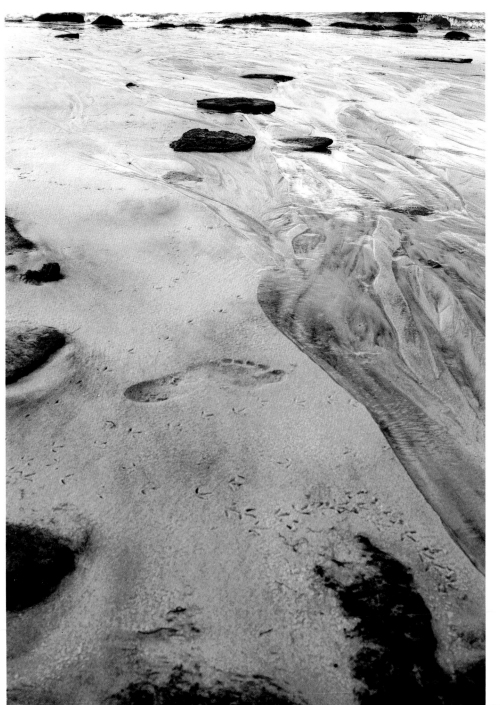

8 *That's better, but looking at the image again I realize that I overdid the Saturation. Now here's the beauty of adjustment layers: while they 'adjust' the colours and tones in the layer below, they don't actually change the values of the pixels underneath. As a result, you can always adjust – even delete – your adjustment layer later, safe in the knowledge that no permanant harm has been done. To reduce the Saturation adjustment, I can simply go to the Layers palette and click on the Hue/Saturation icon sitting in the Hue/Saturation layer. This brings up the Hue/Saturation dialog with the settings previously applied. To reduce the colour, move the Saturation slider to the left. If I had also wanted to go back and tweak the original Levels adjustment, I would simply need to click on the Levels icon on the Levels layer.*

9 *The final image now has much more punch, and the focus of the image, the juxtaposition of the man's foot with those of the bird, is much more prominent.*

Using blending modes

Of all the powerful image-editing capabilities offered by Photoshop Elements (and other image-editing packages, such as Paint Shop Pro) perhaps the least understood are the blending modes. Extremely powerful and versatile, blending modes can be used both to fix problem images and to create striking special effects.

The fact that entire books have been written about blending modes goes some way to demonstrating just how versatile these tools are. Here, we'll have to settle for showing what can be done in a few examples – as a method of correction and as a creative tool. Later projects also use blending modes as part of the tutorials. Once you've seen how they have been employed in these examples, I hope that you'll have the confidence to try out some other combinations for yourself – in fact experimenting is the best way of learning what blending modes can do for you!

Fixing underexposure

1 | *This image, taken indoors without the use of flash, has come out badly underexposed. While there are a number of ways to fix this in most image-editing packages (including using the* Levels *command), here, to show how versatile blending modes can be, we're going to use the* Screen *blending mode.*

2 | *In the* Layers *palette drag the Background layer on to the 'Create a new layer' icon (Ctrl+J for Windows/Cmd+J for Mac). Now change the blending mode of the duplicate layer to Screen. Instantly the image appears much brighter. Additionally, you can control the effect of the blending layer by reducing the duplicate layer's Opacity.*

Fixing overexposure

1 | Just as blending modes can be used to fix overexposure, so too can they be used to correct underexposure.

2 | To fix an underexposed image, duplicate the Background layer as before, but this time set the blending mode to Multiply, not Screen. The image will become darker, with more detail in the shadow and midtone areas.

Creating a cross-processing effect

The 'cross-processing' effect was traditionally achieved by developing slide film with chemicals that were designed to develop print film. Whether it was first done by design or accident is uncertain, but the effect was hugely popular in fashion photography in the late 1980s and early 1990s. The cross-process look is characterized by saturated colours and high-contrast tones.

TIP

The Overlay blending mode produces a softer result than Vivid Light. For a more extreme effect, try Hard Mix or Linear Light.

1 *This image of children playing in the surf is a suitable candidate for the cross-process effect – there are plenty of bright colours and the image contains a good range of tones.*

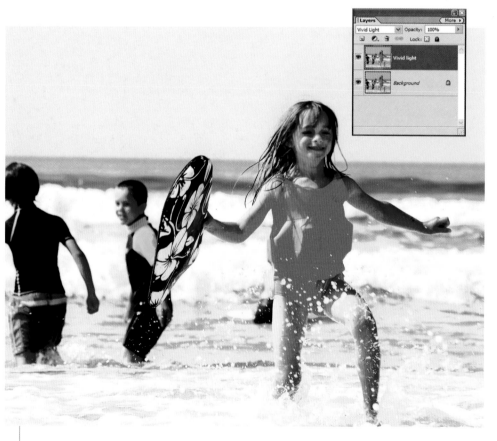

2 *As before, begin by duplicating the original Background image (Ctrl/Cmd+J). There are two blending modes that can create a cross-processed look – Overlay and Vivid Light. In this example, we're going to use Vivid Light. Change the blending mode of the duplicate layer to Vivid Light and look at the result. In this particular case Vivid Light produced an overly strong effect, so the Opacity was reduced to 90%.*

Sharpening with blending modes

Surprisingly blending modes can be used – in conjunction with Elements' sharpening tools – to take greater control of sharpening images. All of us have at some point over-sharpened an image and been horrified by the halo effect that can result – particularly from misuse of the Unsharp Mask filter (see Sharpening, pp.62–3). Blending modes offer a useful way to avoid this.

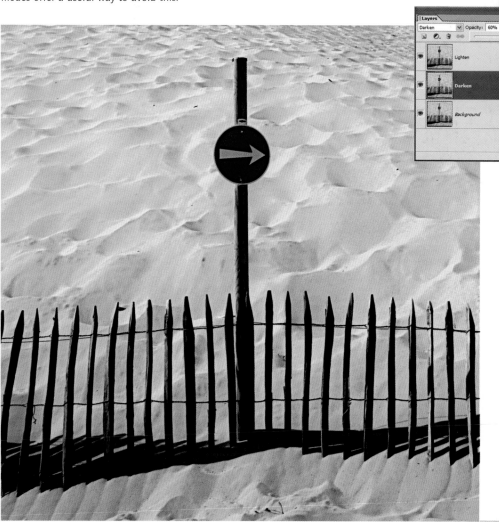

1 | *The fencing in this image is a prime candidate for producing over-sharpened halos if the Unsharp Mask is not used with due care.*

2 | *Go to* Filter > Sharpen > Unsharp Mask *and set* Amount: 200; Radius: 8; Threshold: 4. *Naturally, with these high settings the halo effect will be more than apparent, but don't panic. Duplicate the Background image twice by hitting Ctrl/Cmd+J twice. Set the blending mode for the first duplicate layer to* Darken *then set the second layer's to* Lighten. *Now experiment with the Opacity slider on both duplicate layers until you achieve a natural-looking sharpening without halos.*

The Unsharp Mask works by finding an edge, then lightening pixels on one side and darkening pixels on the other. You're helping the filter do its job.

Soft focus – street scene

This shot of a Provençal shop, 'The Olive Tree', was taken in a small hill-top village in southern France. The baskets and brown-washed walls complement each other, while the ivy adds further texture and an extra colour dimension. It's a good subject for a picture postcard, and could be made even more romantic with a soft focus effect.

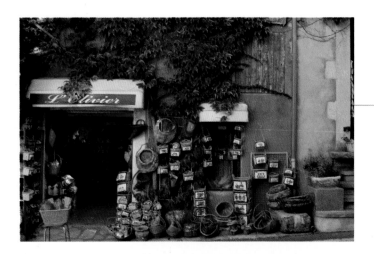

1 | *Open the image that you want to apply the soft focus effect to; in this case 'The Olive Tree' shot. Now make any necessary basic image-editing corrections, such as sharpening, colour correction or altering the brightness levels as shown earlier in the book.*

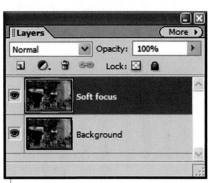

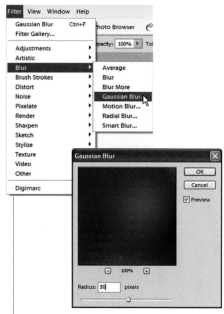

2 | *Next duplicate the Background layer either by going to* Layer > Duplicate Layer *or by using the keyboard shortcut Ctrl/Cmd+J. Call the new layer 'Soft Focus'. Alternatively, go to the* Layers *palette and drag the layer thumbnail over the 'Create a new layer' icon at the top left of the palette. Click to highlight the filename, and then rename it.*

3 | *With the Soft Focus layer selected, go to* Filter > Blur > Gaussian Blur. *Normally this filter is treated with caution and only relatively small values are used, but this is one time when you can use a high value. – 30 pixels works well for this image.*

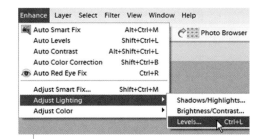
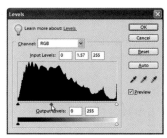

4 | *What I like about soft-focus images is their light and airy quality, so the next step is to increase the brightness levels of the Soft Focus layer. Go to* Enhance > Adjust Lighting > Levels *to bring up the* Levels *dialog box. Drag the gamma point (the centre triangle) to the left to brighten the whole image. At this stage the image is unrecognizable, but don't worry. We have just created the ghosted shapes and light tones that help create the soft focus effect.*

5 | *To put back the missing detail we need the background image to show through. Go to the* Layers *palette and reduce the* Opacity *of the Soft Focus layer to around 50%. You can now fine-tune the effect by decreasing or increasing the Soft Focus layer's* Opacity. *When you're happy with the effect go to* File > Save *(Ctrl/Cmd+S).*

Recreating depth of field

Depth of field is a photographic term used to describe those areas in front of and behind the central point of focus that still appear sharp to the eye. Determined by factors such as the focal length of the lens, the aperture setting and the distance from the camera to the subject, depth of field can be used creatively to draw attention to a specific part of the image.

In conventional film photography, once the various parameters outlined above have been set and the photograph taken there's no going back. You're stuck with the resulting depth of field.

However, with digital imaging it's possible to recreate the effect after the event, by deliberately blurring sections of the photograph in front of and behind the main point of interest.

1 | *Ironically I took this shot to illustrate the effect of depth of field. However, while there are regions of the photo that are sharper than others, it still fails to show the phenomenon. I really wanted to draw focus along the line of the Cayenne peppers and their neighbours. Let's help it along a little.*

2 | *Select the* Rectangular Marquee *tool from the Toolbar, and draw a rectangle along the bottom third of the image. We're going to throw this part of the image out of focus.*

3 | *We need to ensure that the boundary between what is and is not in focus is not too obvious, or the whole effect looks fake. Go to* Select > Feather, *and in the resulting* Feather Selection *dialog set a* Feather Radius *value of around 150 pixels.*

4 | *Having made the selection, go to* Filter > Blur > Gaussian Blur. *For this image I've set the* Radius *to 8. This tool works best if you avoid really high values. When the foreground looks naturally out of focus hit Ctrl/Cmd+D to deselect the selection.*

It can often be very hard to see how an adjustment is shaping up when there are dotted lines all over the place. To hide the selection lines hit Ctrl/Cmd+H and they will all disappear; but remember the selection is still active, even if you can't see it!

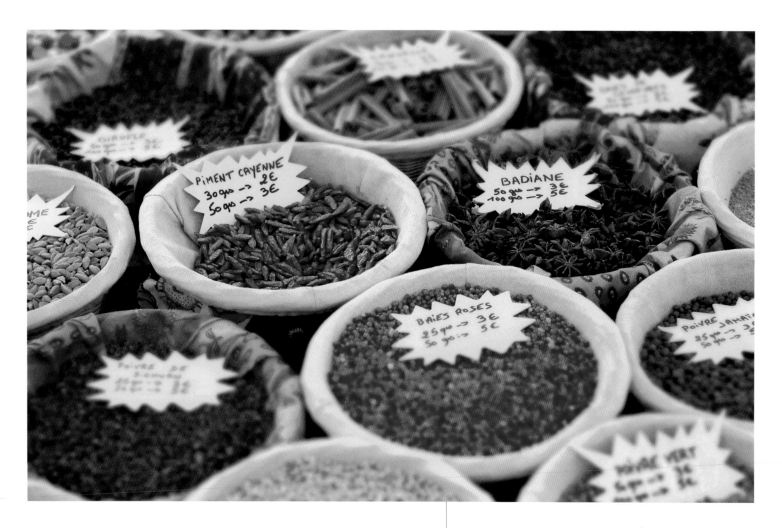

5 | *Now that the foreground has been thrown out of focus, repeat the same exercise for the background, remembering again to* Feather *the selection. The final result is closer to how the original shot should have looked.*

High-key effect

High-key images are characterized by very light tones with little contrast. Becoming popular in the 1950s and 1960s, they were created using multiple, very bright light sources. Unlike an overexposed image, a high-key image, although emphasizing light tones, does include small areas of dark tones that help to balance the image.

1 | *The almost dream-like nature of this image, combined with an open airy quality, makes it an ideal candidate for a high-key effect.*

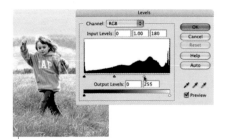

2 | *Begin by opening the* Levels *dialog (Ctrl/Cmd+L). Click on the white point slider at the bottom right of the histogram and drag it to the left to increase the brightness. How far depends on the image. Here I settled on an input value of 180.*

3 | *Duplicate the Background image either by going to the Layers palette and dragging the Background thumbnail over the 'Create a new layer' icon or by using the keyboard shortcut Ctrl/Cmd+J.*

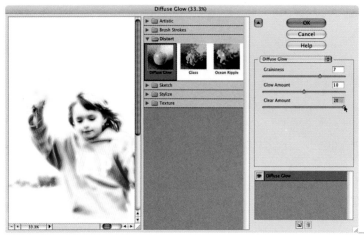

4 | *To soften the image and increase the lightness levels go to* Filter > Distort > Diffuse Glow. *Experiment with the three sliders until you've achieved a light glowing effect. For this image I used* Graininess: 7; Glow Amount: 10; Clear Amount: 20.

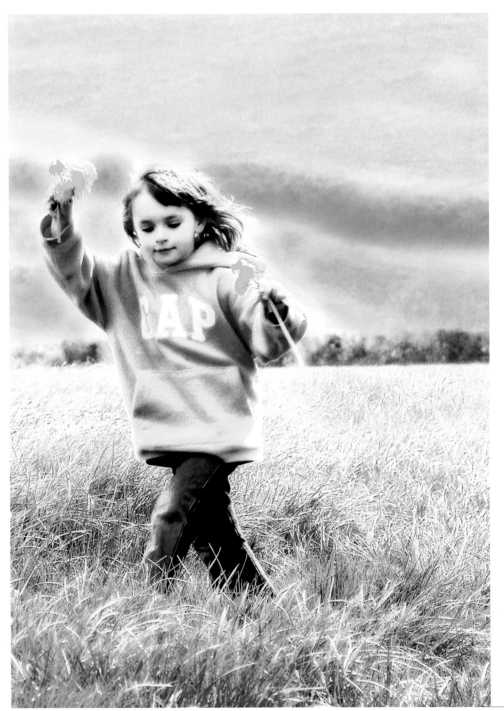

TIP

If you cannot see the image in a filter's preview window, try clicking the minus sign at the bottom left of the dialog box.

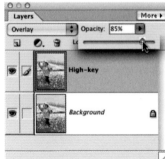

5 | *Return to the* Layers *palette and change the blending mode of the 'High-key' layer. Screen often works well, but having experimented with other modes, I found that* Overlay *gave this particular image a punchier feel while still retaining the high-key look. The result, however, was quite harsh, so I reduced the layer's* Opacity *to 85% to allow the Background layer to show through. Finally, go* Layer > Flatten Image *and then save it (Ctrl/Cmd+S).*

Filters and lighting effects

Most image-editing programmes feature filter effects that can enhance your images in all sorts of ways – some simply replicate traditional darkroom processes or photographic lens filters, while others give your work a range of weird or artistic styles. Photoshop Elements now features many of the filters and lighting effects that were once only available in the full version of Photoshop. Here we're going to take a look at a small sample.

Photo Filters

The Photo Filters are relatively new to Photoshop Elements. As the name suggests, this group emulates the effect of adding a variety of coloured filters to the end of the camera's lens, usually to either warm or cool down an image, or give it a specific colour cast.

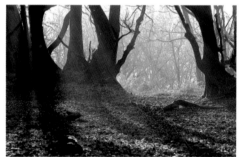

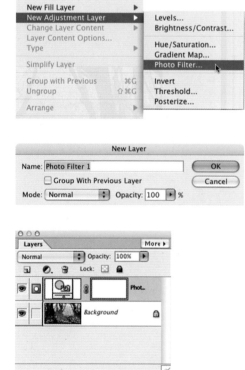

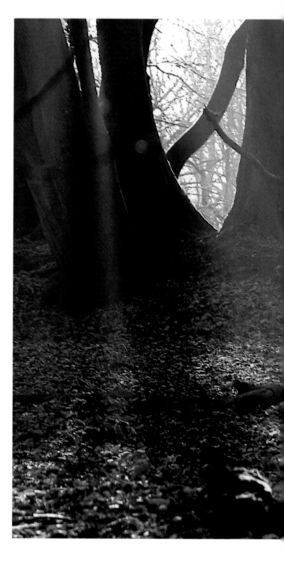

This image was shot during late afternoon; however, with the camera's White Balance set to Auto, the warm sunlight has been neutralized. Photo Filters will help us bring it back. 1

Begin by going to Layer > New Adjustment Layer > Photo Filter. As with all adjustment layers, Elements asks what you want to call the layer – 'Photo Filter 1' is a sensible default, so click OK. You'll see the new layer appear in the Layers palette. 2

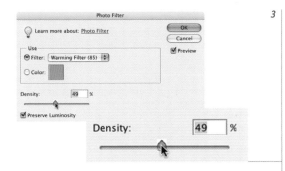

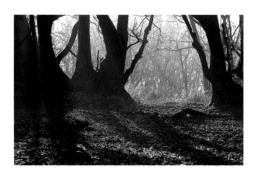

3 | *Having clicked OK, the Photo Filter dialog will appear.* Photo Filter's *default setting is* Warming Filter (85) *set at 25%. (The 85 refers to the standard number given to this shade of warming filter. Another,* Warming Filter (81), *has a slightly more yellow cast).* Warming Filter (85) *is what we need here, but let's increase the percentage to around 50%. Remember to click the* Preview *button on and off to gauge the adjustment. The image now has a proper late afternoon feel.*

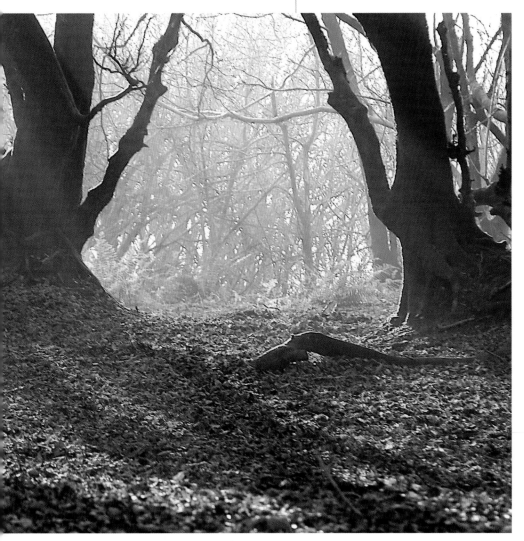

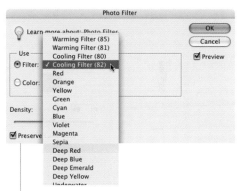

4 | *Although not particularly appropriate for this image, here's the effect of running a* Cooling Filter (82) *on the image.*

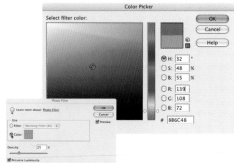

5 | *You don't have to restrict yourself to the many presets available. If you click the* Color *button in the* Photo Filter *dialog window the* Color Picker *window appears, and you can use this to select any colour you want.*

Filter menus

The main Filter menu, which you've already accessed to run the Unsharp Mask filter, contains a mind-boggling number of creative options. There are too many to show here – in fact entire books have been written about Photoshop's Filter set. Let's take a look at one or two. Once you've tried these, you can experiment with others.

1 | *Matching the right filter with the right shot is a skill you learn with experience, but – as always – experimentation is the best way to learn. Using this simple, bright image as a starting point, go to* Filter > Filter Gallery.

2 | *For some reason Elements doesn't list all the filters available in the* Filter Gallery; *the* Adjustments, Noise, Pixelate, Render *and* Sharpen *filters have to be accessed directly from the* Filter *menu. However, let's look at the filters available in the* Filter Gallery *first as these give us a chance to preview the filter before we apply it to an image.*

3 | *Over time, you'll learn that some of the filters are little more than gimmicks, while others can provide useful enhancements, particularly when combined with the original image using blending modes. The permutations are countless. Here I've double-clicked on* Palette Knife *and experimented with the various sliders. The final effect is quite painterly.*

4 | *Here I've chosen* Diffuse Glow. *Even on its own it can produce a dreamy soft-glow effect, but it usually works better when you duplicate the original image as a new layer, apply the filter, then combine the result with the original image. The best way to get to know the filters and how they work is by experimenting with various images and playing around with the sliders.*

5 | *Now let's have a look at one or two of the filters that are not available in the* Filter Gallery. *Here I've gone to* Filter > Pixelate > Mezzotint *and selected* Long Lines *from the pull-down menu. As you can see, the trouble with many of the filters accessed through the main* Filter *menu is that they do not provide a very sophisticated preview window. With* Mezzotint *for example, you cannot adjust the scale of the preview, nor is there a* Preview *box that you can toggle on and off to see the effect on the image. You can only apply the filter, and if you're not happy with the effect hit* Ctrl/Cmd+Z *to undo.*

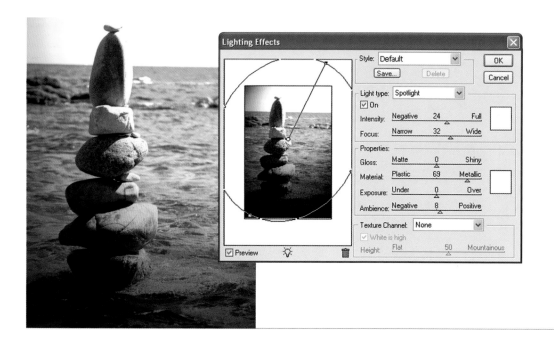

6 | *One of the most useful group of filters – and another that is not accessible through the* Filter Gallery *– is the* Render *group. This includes the superb* Lighting Effects *filter: a powerful feature, albeit a complicated one to learn.* Lighting Effects *allows you to simulate the effects of complex lighting set-ups on your images – which is ideal if you do not have the time or the money to experiment with such things for real. Again, the only way to really learn about the* Lighting Effects *filter is to experiment.*

Styles and effects

To make matters even more complicated, you can find more effects in the Palette Bin, in the palette marked Styles and Effects. While these are probably the least useful of all the filter sets, there are one or two effects that you may find helpful.

1 *When you access the* Styles and Effects *palette, you will see two pull-down menus at the top. Clicking on* Filters *gives you access to most of the filters available via the main* Filter *menu. However, if you select* Effects *in the left-hand menu and* Image Effects *in the right-hand menu, you will discover some other effects not available anywhere else. Here I've double-clicked on* Quadrant Color. *The result is what the name of the effect suggests.*

2 *By clicking on the right-hand pull down menu and selecting* Frames, *you will be presented with a number of frame options. Some are not bad; others are not worth bothering with. Here I've double-clicked* Ripple Frame. *The extent to which your frame will encroach on the image area depends upon resolution: the higher the resolution, the less impact the frame will have. Unfortunately, you will quickly discover that with images set for a print resolution of 240 ppi or above these borders have an almost negligible effect.*

Enhancing skies

Skies are a significant element of many photographs, particularly in wide-angle landscape shots. However, ensuring that the land is correctly exposed can have negative effects on the sky, resulting in one that is overexposed or washed out. This can be remedied at the time of taking the photo by using a grey gradient filter, but such filters are not always available. In that case, Elements can reintroduce some contrast when the photo is edited.

1 *This image of a surf school heading for the waves was taken in the mid-afternoon. Correctly exposing for the surfers has resulted in a washed out sky, lessening the impact of a potentially attractive group of white clouds in a deep blue sky.*

2 *Begin by creating a new layer either by going to* Layer > New > Layer *(Ctrl/Cmd+Shift+N) or by clicking the 'Create a new layer' icon at the top left of the* Layers *palette. Call the new layer 'Sky'.*

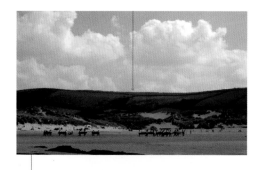

3 *Next ensure that the foreground and background colours are set to black and white (hit the D key). Select the* Gradient *tool (G) and ensure that the* Gradient *type is set to* Linear *in the* Tool Options *bar. While you're there, click the* Edit *button and select the* Foreground to Transparent *option.*

4 *Holding down the Shift key (to ensure you draw a straight, vertical line), drag the gradient cursor down the centre of the image from the top of the photo to the bottom of the sky.*

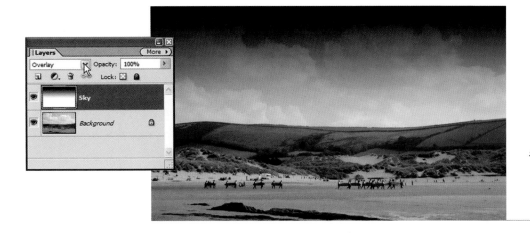

5 | As soon as you release the mouse button a graduated grey tint will appear over the sky. To convert this tint into a contrast-boosting layer, return to the Layers palette and change the Sky layer's blending mode to Overlay.

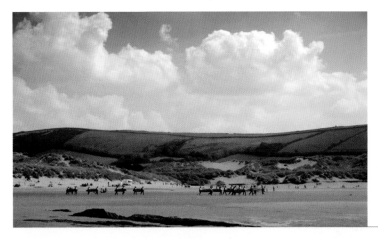

6 | This change of blending mode should result in a more saturated blue sky and some attractive, prominent white clouds.

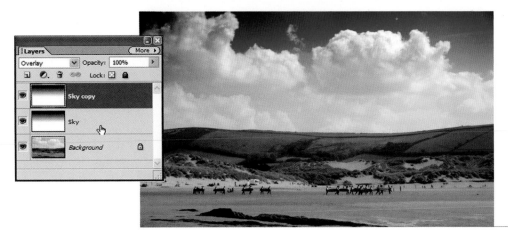

7 | Perhaps one application is not sufficient? Well, by copying the Sky layer (either by dragging the Sky layer over the 'Create a new layer' icon in the Layers palette or by hitting Ctrl/Cmd+J) you can intensify the effect.

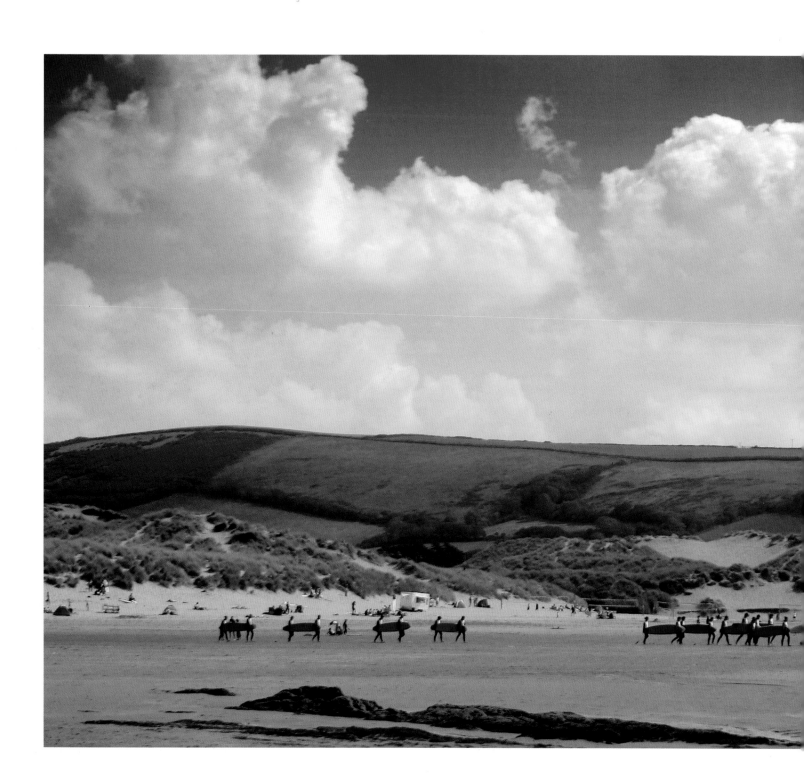

You can get some useful effects by experimenting with gradients and other blending modes. Overlay and Multiply work well, but try Color Burn, Linear Burn and Soft Light. Vary the Opacity if the effect is too strong.

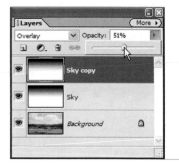

8 | *I felt that a double application of the Gradient treatment had created an unnatural-looking sky. To remedy this, simply reduce the Sky copy layer's Opacity* in the Layers *palette to around 50%. As soon as you're happy with the result go to* Layer > Flatten Image, *then to* File > Save *(Ctrl/Cmd+S).*

Adding text

Being able to add text gives you the ability to turn some of your favourite images into personalized greeting cards, calendars, or CD covers – the list is endless. Furthermore, Elements has an enormous number of preset styles that allow you to ensure the style of the text matches the image or occasion. It is important to get the right 'feel'.

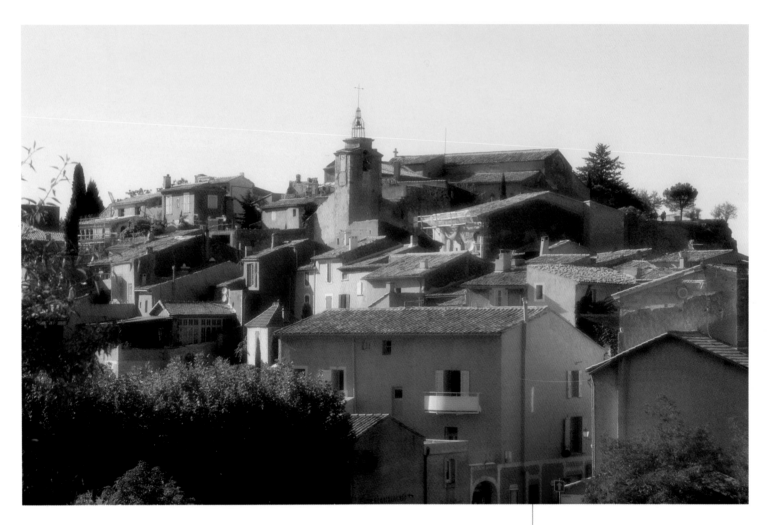

1 | *In this simple exercise we're going to create a postcard by adding some text to this photo of a hillside village in Provence.*

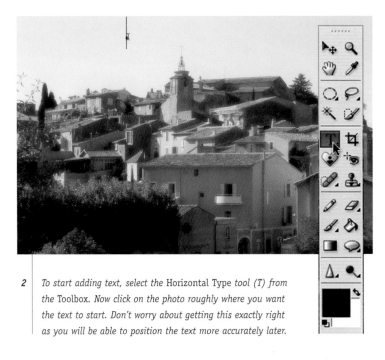

2 | To start adding text, select the Horizontal Type *tool (T) from the* Toolbox. *Now click on the photo roughly where you want the text to start. Don't worry about getting this exactly right as you will be able to position the text more accurately later.*

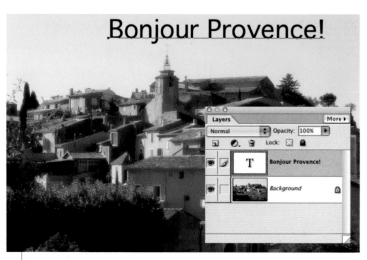

3 | *Type in the message you want to put on your image. Once you have finished typing the text, take a look at the* Layers *palette. You will notice that Elements has automatically created a new layer for the text.*

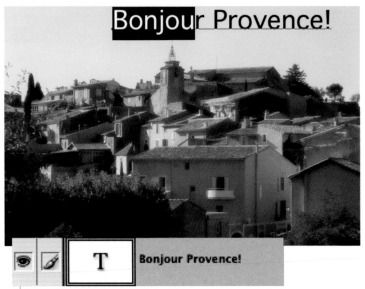

4 | *To change the size and the style of the text, ensure the Type layer is selected in the* Layers *palette. Now, with the Horizontal Type* tool *click at the beginning of the text and, holding the mouse button down, drag along the text to highlight it.*

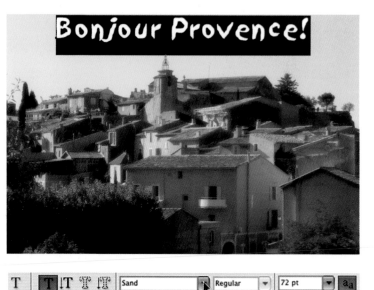

5 | *Go to the* Tool Options *bar and select an appropriate type size (here I have selected 72 points) from the type size pull-down menu and a good looking font from the font pull-down menu (here I have chosen* Sand*).*

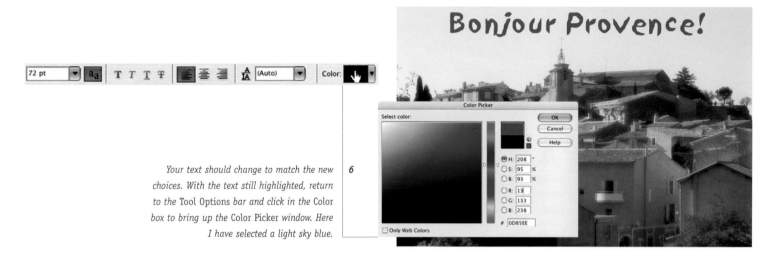

*Your text should change to match the new
choices. With the text still highlighted, return
to the* Tool Options *bar and click in the* Color
box to bring up the Color Picker *window. Here
I have selected a light sky blue.* **6**

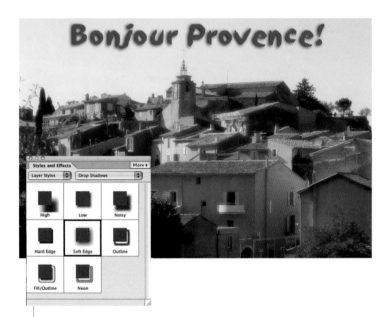

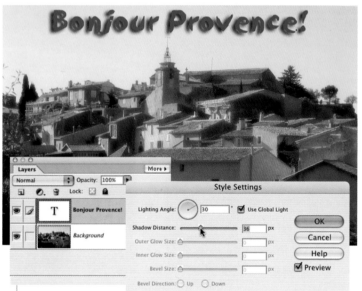

7 | The text looks better, but there's more we can do. To give it some body and depth,
go to the Styles and Effects *palette. Select* Layer Styles *in the left-hand pull-down
menu, and* Drop Shadows *in the right-hand menu. This brings up a number of
preset drop shadow effects. As always, try experimenting with the various options
by clicking on them. Here I settled on* Soft Edge.

8 | Next, return to the Layers *palette and double-click the small icon that looks like
an 'f' in the Text layer. This will bring up the* Style Settings *box, where you have
the option of increasing the drop shadow's distance. I've increased the* Shadow
Distance *to 36 to give the type more depth.*

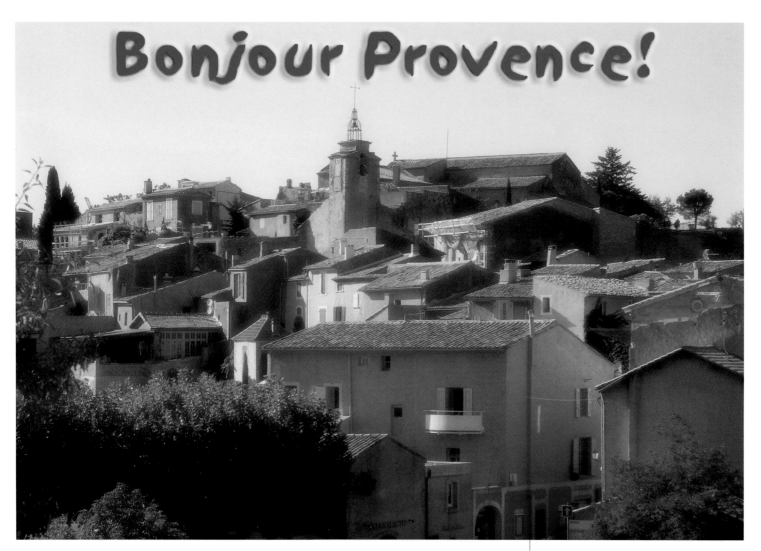

Bonjour Provence!

9 *To finish the type, return to the* Styles and Effects *palette and change the right-hand pull-down menu to* Outer Glows. *Again, experiment with the various preset options. In this example,* Blue Ghost *seemed to work best. This* Outer Glow *effect creates an almost 3-D effect, so that the type looks as if it has been raised up from the surface of the image.*

Sharing your images

Printing

Now that we've covered the basic and more advanced image corrections, we need a way of sharing the finished photographs. The easiest way is the oldest way: by printing them out to frame or just to show to family and friends. Printing is easy, but there are one or two things to look out for.

TIP

At times, Elements mistakenly throws up a message suggesting that your image will print out at a resolution of less than 220ppi. Double check your image-size (Ctrl/Cmd+Shift+I), and if the dialog says 300ppi or above, don't worry.

1 | *Here's the image we're going to print. It's a high-resolution image (3354 × 1462 pixels) from an 8-megapixel camera, so it can easily make a 10 × 8-inch print.*

2 | *To begin printing, either go to* File > Print *(Ctrl/Cmd+P) or click the printer icon in the main* Menu Bar *at the very top of the Elements screen.*

3 | *Once you've selected* Print, *you'll be shown the* Print Preview *dialog. The first thing you notice with this particular example is that the orientation of the image is incorrect for a landscape image. To fix this click the* Page Setup *button.*

120

4 | *The* Page Setup *window contains five main options. Leave* Settings *at Page Attributes. Next to* Format for: *select the printer you wish to print to. Now ensure that* Paper Size *is set to the size of the paper you want to print on – in this case* A4 *(the closest to the standard size of paper for 10 × 8 prints). For this example, change the* Orientation *to* Landscape. *Leave* Scale *at 100% and click* OK.

5 | *Having clicked* OK, *you will return to the* Print Preview *window. Now you can see that the image is orientated correctly. However, when you look at* Print Size *at the top of the window, you can see that while the page size is deep enough for the image (8 inches vs 6.09 inches) the length of the image is too great for the page size (13.98 inches vs 10 inches). Let's fix this next.*

6 | *Use the* Print Size *pull-down menu, but don't select the more intuitive 8 × 10 option. Instead, opt for* Fit On Page. *Although the image now fits the A4-size paper, there is no border at either end of the image.*

7 | *To adjust the image so that there is at least some border on every side, return to the* Print Size *menu and this time select the* Custom Size *option. Although this looks almost identical to the* Fit On Page *option, there is one important difference. As long as* Show Bounding Box *is checked, you should be able to see four small boxes sitting on the corners of the image.*

8 | *Move the mouse cursor over one of the bounding box corners and you will notice the familiar two-headed arrow for resizing. Now, while holding down the mouse button, move the cursor in until the image has white space all around it. There's no need to hold down the shift key to ensure that the image retains the correct aspect ratio – Elements will do that for you automatically. When you're happy with the preview, click* Print *to bring up the* Print *dialog window.*

9 | *In the* Print *window you may find that you have to reselect your printer. In* Presets *set the types of paper you want to print on; here I've selected* Glossy. *Leave* Copies & Pages *untouched (although you should explore what the other settings can do as there are some useful functions). As soon as you're happy with the various settings, hit* Print *and wait for the results.*

Adding borders

Adding a border to a favourite image can help to make a good photo even better. There are numerous ways of creating borders within Photoshop Elements, though some are more complex and some more effective than others. The method described here is just about as straightforward as it gets, but can still yield pleasing results in a matter of minutes.

1 | *Begin by opening the image to which you want to add a border. Make any adjustments to the image, such as sharpening or fixing the brightness levels. Here I've simply turned the image to a black and white, greyscale photo. (See Converting to black and white, pp.132–3)*

2 | *Next, go to the Toolbox and select the Eraser tool (E).*

3 | *In the Tool Options bar ensure that the Mode is set to Brush, then click on the small, black arrow next to the selected brush image. This will bring up the preset brush menu. As always, it pays to experiment with the various brushes, but for this example I've selected a good-sized spatter. Set the Opacity slider to around 70% and select a Size appropriate to your image.*

4 | *Carefully begin to erase the hard edge of the photograph, so that the shape and texture of your selected brush becomes visible. You may need to practise this a few times, so do not forget to use the Undo History palette if you're not happy with any erasing strokes.*

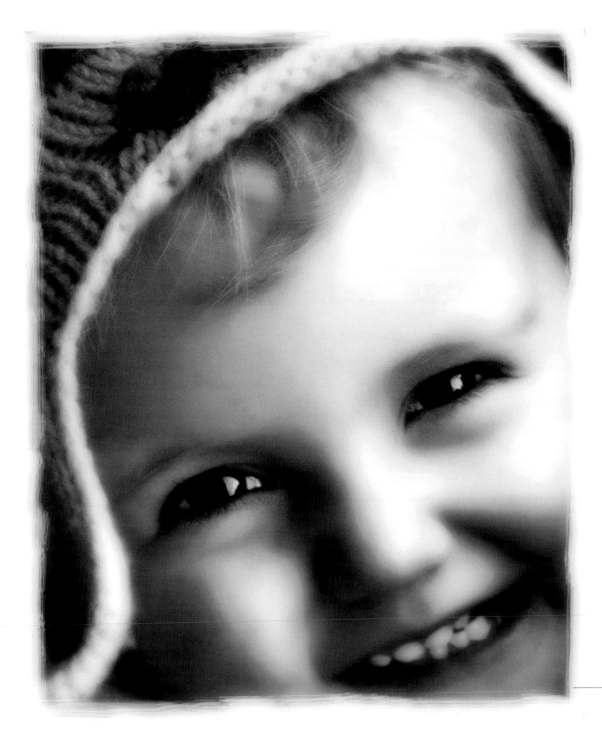

TIP

You can adjust the size of brushes quickly and easily by using the '[' and the ']' keys.

5 | *Once you've gone around all four edges once, try adjusting the type, size and opacity of the brush and go around the edges one more time to create a more uneven edge. Remember to keep trying different brush types and sizes to create interesting borders. When you're happy with the border, save the image (Ctrl/Cmd+S).*

E-mailing images

Printing images or placing them on a Web page is one way to share a favourite photograph, but for a direct approach why not try e-mail? Photoshop Elements can e-mail images straight from the programme, without any need to optimize them first. This can save an enormous amount of time, particularly if you want to send several images at once.

1 *To e-mail a batch of images, go to* Standard Edit *or* Quick Fix *edit modes, and click on* Photo Browser *in the Menu Bar. This will load the* Organizer *window in which you will find all the images that you've downloaded so far. Click on the* Collections *tab at the right of the window and in the* New *pull-down menu select* New Collection. *In the resulting* Create Collection *dialog window give your new collection an appropriate name and – while you're there – add any notes that you may find helpful in the future. Don't worry about editing the icon at this stage. Click* OK.

2 *As soon as you click* OK *in the* Create Collection *window a new question mark icon will appear in the* Collections *palette. Now click on the camera icon in the Menu Bar, and select the way in which you want to add images to the* Organizer; *here I've selected 'From Files and Folders'. Elements will now show a* Getting Photos *progress window.*

3 *Once the download is complete, Elements reminds you that the images you've just downloaded are the only ones visible. This is helpful, as it makes identifying the images you've downloaded easier. Drag the question mark icon on the first thumbnail in the* Organizer *window, and the icon becomes a thumbnail of the first tagged image. Repeat the*

process, and a small icon will appear in each of the tagged images' window to indicate the image has been tagged. As soon as you've tagged all the images, click on the small box next to the new icon in the Collections *palette. A small icon of a pair of binoculars will appear, and the only images visible in the main window will be those you've tagged.*

Click on the Share *icon in the* Menu Bar, **4**
then select E-mail *from the menu. Now*
select the recipient of the collection and the
e-mail software you use. Notice how, in this
example, Elements has reduced a collection
of 12 high-resolution images from a total of
240Mb to a more e-mail-friendly 1.6MB.

5 | *Before sending the e-mail, Elements allows you*
to customize it using a variety of presets which
alter the overall look and feel. Play around, and
pick something you like.

6 | *When you've finished customizing your e-mail,*
click Next. *In this case, because the e-mail exceeds*
1MB a warning dialog has appeared. If you know
that the recipient's e-mail can accept e-mails of at
least 1.6MB click OK *(if you're not sure, it's wise*
to ask them first). You're now ready to e-mail the
collection – simply click Send *in the top left-hand*
corner of the e-mail window.

Creating a slide show

One of the most enjoyable and relaxing ways of viewing your photographs is to create a slide show of a selection of images. Not only can you view your slide show on your own monitor, but as you'll see, you can also e-mail it to friends and family, save it to a disk, or even send it to your television.

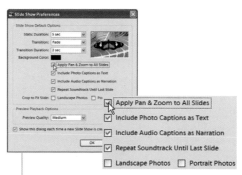

1 | *In either* Standard Edit *or* Quick Fix *edit modes click the* Create *button in the* Menu Bar. *This will bring up the* Creation Setup *window. Select* Slide Show *and click* OK.

2 | *The* Slide Show Preferences *window presents you with various options, including how long you want your image to be shown, the* Transition *and so on. The settings shown are the defaults, apart from* Apply Pan & Zoom to All Slides, *which I selected.*

3 | *Having clicked* OK, *the* Slide Show Editor *window will appear. Click the* Add Media *button and, depending on where your images are selected, choose either* Photos and Videos from Organizer *or* Photos and Videos from Folder.

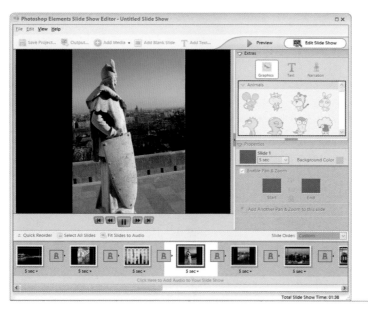

4 | *Clicking* Photos and Videos from Organizer *enables me to select all the images from the* Hungary 2006 *collection. Having identified which selection to use, click* Select All, *then* Add Selected Photos.

5 | *With all the selected photos added to the* Slide Show Editor, *it's time to edit the presentation.*

6 | *The* Slide Show Editor *window contains a huge number of preset options. Clicking on the* Background Color *button, for example, brings up the* Color Picker, *using which you can select any colour you like for the background.*

7 | *The* Graphics *palette contains a host of features that you can add to individual slides. Here, I've selected a border and, holding down the mouse button, dragged it over the slide. You can use the bounding box to fit the border to the image.*

8 | *By returning to the* Add Media *button at the top of the screen it's also possible to choose music you wish to accompany the slide show. Once you've selected the music you want, it will appear as a timeline at the bottom of the window.*

9 | *One of the more useful options in the* Slide Show Editor *is the ability to add text. Click the* Text *button in the right-hand palette window. Select the style of text you want to use and click and drag the* T *icon on to the image. Click the* Edit Text *button and type in your text in the* Edit Text *window. Finally click* OK. *To preview the slide show, click the* Preview *button at the top right-hand corner of the window. This hides the interface that usually surrounds the central image window, so that you can see what the finished slide show will look like. Click the* Play *arrow.*

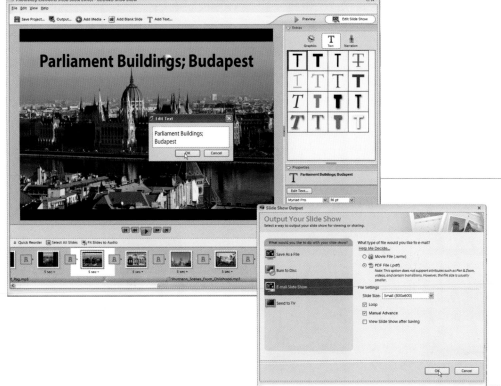

10 | *To save the slide show, click* Save Project *in the* Menu Bar *and then, in the text box that appears, just type in a suitable name for your show.*

11 | *Finally, clicking the* Output *icon will bring up the* Slide Show Output *window. Select one of the four options and follow the instructions.*

Saving images for the web

If you have your own website, or often submit images to a photography website – or any other type – you need to 'optimize' your images for the web. All this means is that you have to save your image with the file size as small as possible, while trying not to compromise on image-quality. It's a tricky balance, but Elements has tools to make it easy.

1 | The best place to start saving an image for the web is to reduce the image's file size by going to Image > Resize > Image Size *(Ctrl/Cmd+Shift+I)*.

2 | In the Image Size *dialog window, click on the box labelled* Resample Image *and ensure it's ticked. Now, in the* Pixel Dimensions *box change the width to 600 pixels. At this size the image will be viewable on just about all monitors without having to scroll the image on-screen.*

Save ⌘S
Save As... ⇧⌘S
Save for Web... ⌥⇧⌘S

Attach to Email...
Create Web Photo Gallery...

🔍🔍 Zoom: 100% ▶ ☐ Resize Windows To Fit ☐ Ignore Palettes ☐ Zoom All Windows **Actual Pixels** F

3 | Now pick the Zoom *tool (Z) from the* Toolbox. *Go to the* Tool Options *bar and select* Actual Pixels. *The result shows exactly how large the image will appear on the website. If you're happy with how the image looks go to* Image > Save for Web.

4 | *This dialog shows you your original image on the left and the image as it will be saved on the right. Set the* Zoom *level to 800% in order to gauge how the image degrades, then go to the right-hand side of the window and select* JPEG Low. *With these settings the image would only take a second to load with a 512K broadband connection, but the quality has degraded quite badly.*

5 | *To improve the quality set the JPEG setting to* Very High. *With this small amount of compression, the image looks pretty good. Go to* Zoom *and select 100%, then move around the image to check the quality. Now see how long it will take to upload – in this case 3 seconds with a 512K broadband connection. Although this doesn't sound much, it will feel slow to people browsing the site. To help remedy this, click the* Progressive *button. This ensures that the image will appear very quickly on screen and then become increasingly sharp until it reaches its full resolution after 3 seconds.*

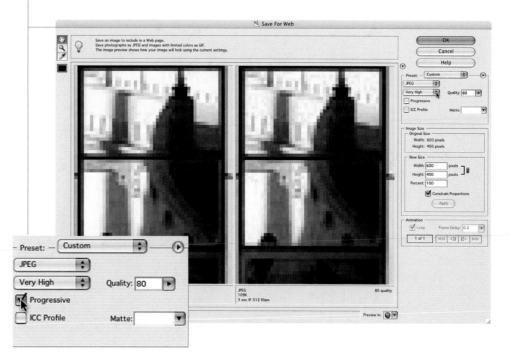

Masterclasses

Hand-tinting

Before the advent of colour photography, the only way to add colour to a photograph was to hand-tint a black and white image. Following the introduction of colour film, this practice became less popular, but it had a resurgence in the 1960s. Traditionally practised using oil paints, it is less painstaking to replicate using image-editing software.

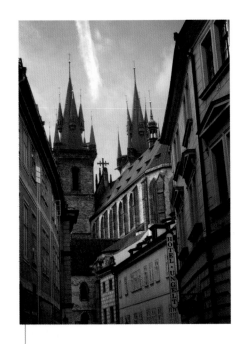

1 | *Begin the hand-tinting process by desaturating your original image. Use* Enhance > Adjust Colour > Remove Color *(or Ctrl/Cmd+Shift+U).*

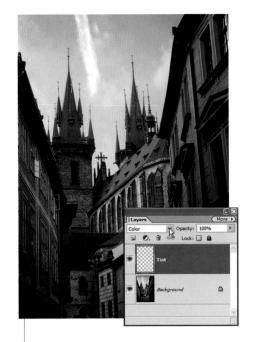

2 | *Before you colour, get the greyscale version in shape by making any necessary* Levels *adjustments. Here, I boosted the contrast. Next, go to* Layer > New > Layer *(Ctrl/Cmd+Shift+N) and call the new layer 'Tint'. Go to the* Layers *palette and change the blending mode to* Color.

3 | *Select the* Brush *tool (B) from the* Toolbox, *then select a soft brush from the* Tool Options *bar. Set the* Opacity *to 50% and click the* Enable Airbrush *icon. It makes the brush scatter paint lightly at first, but more heavily as you hold the button.*

4 | *With the appropriate tools selected you can begin to paint over the greyscale image. Click on the* Set Foreground *square at the bottom of the* Toolbox *to bring up the* Color Picker. *Choose a good starting colour, using both the vertical colour bar to select the broad colour range and the large window to fine tune the selection. Here, I started with a vintage-looking golden brown.*

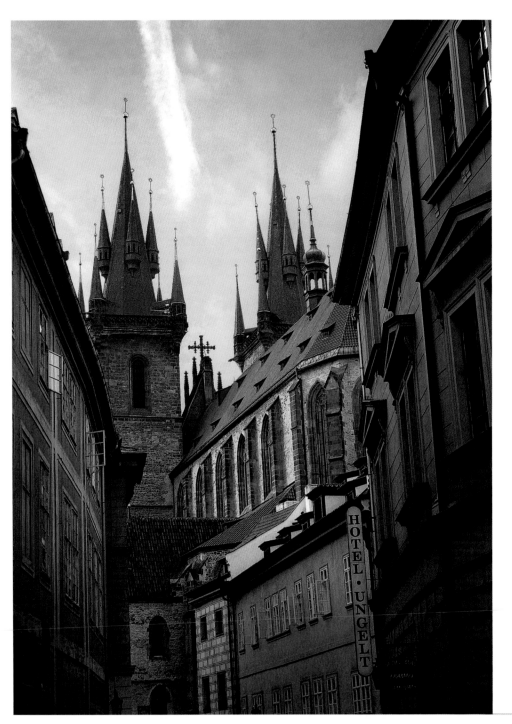

5 *Begin painting over the image with the Brush tool. Remember you can easily change the size of the brush using the '[' and ']' keys. You don't need to be absolutely accurate. Part of the charm of traditional hand-tinted pictures is that they do indeed look hand painted, and have the rough edges to match.*

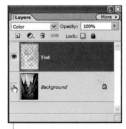

6 *As you paint over the image, you will notice the colour appear in the Tint layer in the Layers palette. It can sometimes help to turn the visibility of the Background layer off by clicking on the eye next to the image thumbnail. Do this, and you will see the tinted layer on its own.*

7 *Now build up the image, colour by colour. The effect works best when you are consistent with your choices: if the brickwork is brown on one side of the building, then it should be the same tone on the other side. The tones of the background layer will ensure the right shadows and tones are in place. When you have completed the tinting process, go to* Layer > Flatten Image *and then save (Ctrl/Cmd+S).*

Converting to black and white

Black and white photography is still revered in photographic circles as the true expression of the art form. It takes practice to 'see' in black and white; what the photographer needs to be aware of is tonal rather than colour differentiation. The advantage of digital photography is that it is possible to retrospectively review colour images on-screen and look for those that will convert well to black and white. This is much more convenient than having to deliberately shoot with black and white film at the time.

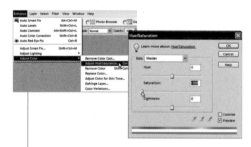

1 | This image of a ruined castle in northern Hungary has the potential to make a strong black and white composition. The blue sky features wispy clouds which will convert nicely, and the castle itself is lit strongly on one side, while another side is cast in shadow, providing good tonal contrast.

2 | The first stage of the conversion is to desaturate the existing image of its colour. Go to Enhance > Adjust Color > Adjust Hue/Saturation (Ctrl/Cmd+U) to bring up the Hue/Saturation dialog box. Now move the Saturation slider all the way to the left until the value reads −100.

3 | Desaturating the image of its colour produces an acceptable black and white image, but the sky is lacking impact. You can create a more striking sky without leaving the Hue/Saturation dialog, so don't click OK just yet.

4 *To do so, you need to remove the residual blue and cyan tones. This makes the blue sky darker, thereby enhancing the white of the clouds. Select Blues from the pull-down Edit menu, and then move the Saturation slider all the way to the left. Repeat this exercise, but this time choosing Cyans.*

5 *Removing the blues and cyans from the black and white image has given the sky more impact – now to increase the contrast between the lit and unlit walls. Select the Dodge tool (O) from the Toolbox, and choose a medium-sized brush with the Opacity set to 30%. Brush over the sunlit wall to lighten it.*

6 *Finally, to add even more contrast to the image as a whole, duplicate the Background layer (Ctrl/Cmd+J). Now change the duplicate layer's blending mode to Overlay and reduce the Opacity to taste – I set the slider to 50%. Now go to Layer > Flatten Image and then save it (Ctrl/Cmd+S).*

Creating panoramas

One of the most exciting and enjoyable aspects of modern digital photography is the ease with which you can make attractive panoramas. If you have a conventional camera, it is still possible to make them, but of course it requires scanning all the images first, then stitching them together before you can start work. With a digital camera, the process is practically automatic.

1 | *Before you start, put the images you are going to stitch together in one folder.*

2 | *Photoshop Elements creates panoramas through a powerful, automated programme. To access this go to* File > New > Photomerge Panorama.

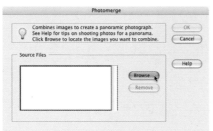

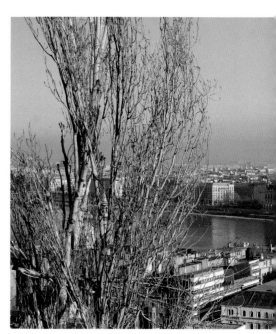

3 | *Use the* Browse *window to navigate to the folder in which you put your images.*

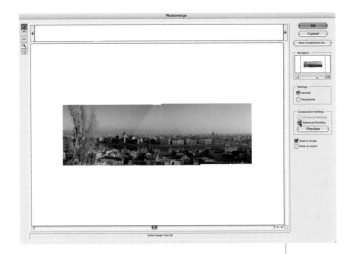

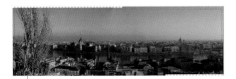

5 Advanced Blending *takes a little longer, but it has improved the panorama dramatically. At this stage I am going to* Crop *the image (see pp.48-9) and finish working on it.*

6 *You can now work on the image in the same way you would on any other. Make any* Levels *adjustments, sharpen the image, and check for any anomalies where images have overlapped.*

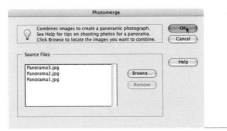

4 *Once you've located all the source files, click* OK. *After a minute or two, depending on how many files there are and the speed of your computer, you will be presented with an initial panorama. The quality of this will vary. Here, Elements has done a pretty good job, but there are obvious stitches in the sky. To help fix this I have selected* Advance Blending *and clicked on the* Preview *button.*

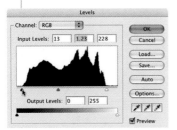

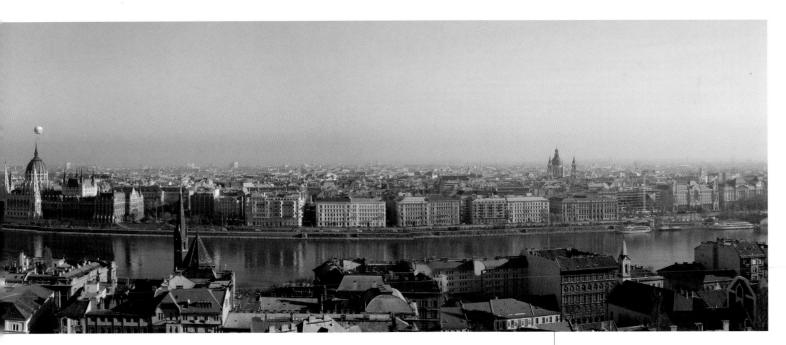

7 *When you have completed making all the necessary adjustments, save the final panorama.*

Glossary

Anti-shake

A relatively recent technology utilized by some camera manufacturers whereby the camera's sensor 'floats' within the camera body and moves independently and in the opposite direction to the camera. The purpose of anti-shake technology is to allow a long-range zoom or a slower shutter speed to be used, while still producing a repectably sharp image.

Artefacts

Visible flaws in a digital image caused by mild sensor failure, lens distortion or in-camera processing. Artefacts come in different forms including noise, chromatic aberration, and compression artefacts.

Autofocus (AF)

The ability of a camera's lens to focus automatically on the subject of a scene when the shutter release is depressed. The lens is focussed by a tiny internal motor and relies on the contrast of the subject to work. Most cameras will make a 'bleep' sound to indicate that focus has been achieved.

Bit

The basic 'unit' of computing. In binary terms a bit is either 1 or 0, which can be thought of as 'on' or 'off'. In digital imaging, a 1-bit image is a pure black (0) and white (1) image (not to be confused with a greyscale image, which can have tones of grey).

Bit-depth

In digital imaging, the amount of colour information contained in each pixel. To emulate a continuous-tone colour image, each primary colour (red, green and blue) has 8 bits (2^8) or 256 different shades. In total this creates an image with $256 \times 256 \times 256 = 16.8$ million colours. Colour JPEG images are often referred to as 24-bit colour images (3×8).

Bracketing

Bracketing involves taking usually three quick successive photos of the same subject; one at the 'correct' exposure as determined by the camera's light meter, one a little overexposed and the third slightly underexposed. The purpose is to ensure that out of the three shots, one will be correctly exposed.

Buffer

A temporary storage device found in many digital cameras. Comprising RAM (random access memory) the buffer will hold a certain amount of digital image information until it can be written to the camera's storage card. The buffer allows the camera to take continuous photos at rapid speed, which is often necessary for fast-action photography.

Burning

A conventional darkroom technique in which an area of an image is exposed for longer than the rest of the image with the intention of making that area darker. A mask is placed over the area not to be burned. In image-editing software, the Burn tool can be used to darken specific areas of an image to emulate the same effect. See also dodging.

CCD (charge-coupled device)

A type of sensor found in most digital cameras. CCDs are made up of an array of millions of photosites, which convert light in the form of photons into an electrical charge. CCDs differ from the other common form of camera sensor, the CMOS, in that the digital conversion takes place on another chip.

Channel

The name given to either one of the red, green or blue 'layers' which commonly make up a colour digital image. An image's three channels can usually be viewed separately in image-editing software.

Chromatic aberration

Sometimes referred to as 'colour fringing', chromatic aberration is caused by slight flaws in a camera's lens in which light of different wavelengths (such as blue and red) are not focussed on the same focal plane. The effect is most commonly seen as a purple outline around strongly contrasting edges.

CMOS

One of the two most common types of sensor used in digital cameras; the other is the CCD. The CMOS type of sensor is actually a computer chip in its own right, which means it can convert the light signal into a digital signal without the use of a separate chip.

Colour filter array

A form of 'screen' that sits over a camera's sensor which filters out the colours from an image into the primary red, blue and green colours. Because our eyes are more sensitive to green light there are usually twice as many green filters as there are red and blue.

Colour temperature

The term used to describe the different colour of light, depending on its source. Colour temperature is measured in degrees K (Kelvin). During the course of a day, for example, light temperature can range from red (2000K) – sunrise and sunset – to blue/white (9000K) – which occurs around midday. Artificial sources of light, such as fluorescent and tungsten lightbulbs also have their own colour temperatures. A digital camera will often have a variable White Balance control to counteract the effect of non-neutral colour temperatures.

Compression

A method by which the amount of image data is reduced to enable more data to fit on storage devices. There are two types of compression, lossy and lossless. Lossy compression involves the discarding of

'unnecessary' information, such as contiguous pixels that contain the same colour and tonal information. Once this information is discarded it can never be recovered. JPEGs utilize a form of lossy compression, which can be set from high compression to low. The higher the compression, the more likelihood of artefacts. Lossless compression, as sometimes used by TIFFs, is a form of 'temporary' compression. When the image file is opened, it 'expands' to the full image file size again.

Continuous tone

The term used to describe a photographic colour image, in which, because the changes in colour and tone are so subtle, our eyes cannot differentiate the actual changes between one colour and the next.

DPI (dots per inch)

The measure of resolution for output devices, such as a printer. A resolution of 300dpi is usually required for a printed page such as those in this book. Not to be confused with PPI (pixels per inch).

Depth of field

The area in front of and behind the subject of a photograph that remains in focus. Depth of field is governed by the focal length of the lens, the aperture setting, and the distance from the lens to the subject.

Digital zoom

Digital camera manufacturers often advertise a camera's digital zoom capability (as opposed to optical zoom). Digital zoom uses interpolation to 'blow up' the existing image electronically so that you appear to be zooming closer to the subject. The result is likely to be pixellated, depending on how much zoom is utilized, and the result is the same as cropping into the area you want to zoom into using image-editing software and then resampling the resulting crop so that it fills the original image area.

Dodging

A conventional darkroom technique in which an area of an image is masked off during part of the exposure so that it is made lighter than the rest of the image. In image-editing software, the Dodge tool can be used to emulate the same effect. See also burning.

Dynamic range

The term used to describe the range between the lightest and darkest parts of an image or scene. The term is also used to describe the range that the sensor in either a camera or scanner can resolve both dark and light areas.

Exposure

The amount of light that strikes an image sensor. Exposure is governed by a combination of the aperture setting and the shutter speed.

Exposure compensation

A feature of many prosumer and all digital SLR cameras in which the camera's exposure reading (governed by the metering system) is manually overridden so that the sensor receives more or less light.

File format

The way in which a digital image is saved to a camera's storage card or on a computer's hard drive. The three most common file formats are JPEGs, TIFFs, and Raw.

Greyscale

Name given to any 'black and white' image that contains the complete range of 256 shades of grey, from pure black to pure white.

Histogram

A diagrammatic representation of tonal range. The horizontal axis represents the tones from pure black (0) on the left, to pure white (255) on the right. The vertical axis represents the number of pixels with each tone.

Interpolation

A method by which a digital image is increased in size by adding more pixels. Achieved using a variety of complex algorithms, pixels are sampled and their tonal and colour values measured before being duplicated. Small amounts of interpolation can be used quite successfully, but too much will lead to artefacts known as jaggies, pixels with a blocky appearance.

ISO (International Standards Organization)

In conventional photography, ISO indicates the light sensitivity of film – the higher the ISO number the 'faster' (more light sensitive) the film. In digital photography, ISO is used to describe the output signal generated by a camera's sensor. By adjusting the signal, a higher or lower 'ISO' setting can be used. A 'normal' setting is around 100 ISO, but in low light a higher ISO of 400, 800 or even 1600 and higher can be used; high ISO settings, however, can lead to noise.

JPEG (Joint Photographic Experts Group)

One of the most common file formats for storing photographic images. The JPEG format is compatible with most imaging and playback devices and can be compressed by a factor of around 15 times before any great loss of image quality.

Layer

A term used in many image-editing programmes. When an image is first opened in the software it is often referred to as the 'Background' layer. Subsequent layers (either additional images or duplicate layers of the first image with filters or corrections applied) can be placed over the background layer to create the final printed image.

Manual focus

The ability to manually focus a camera's lens. Manual focus allows the photographer to take greater creative control, by adjusting depth of field for example.

Mask

The ability in some image-editing software to select a specific area of an image so allowing for localized correction or to create cut-outs.

Megapixel

Literally 1,000,000 pixels; hence a 5-megapixel camera features a sensor capable of producing an image with 5 million pixels. The higher the megapixel count, the greater the camera's resolution.

Memory card

Generic term for the various removable storage devices found in digital cameras. Memory cards come in different shapes – CompactFlash, Memory Stick, SD and XD memory card being the most common – and in various sizes and capacities (ranging from about 16Mb to 4Gb). Most cameras are only capable of taking one or two different types of memory card. When the card is full, it must be removed from the camera and the images downloaded to a computer or other larger storage device before the card can be reformatted for further use.

Metering

Conventional and digital cameras have one or more metering methods which are used to determine the correct exposure. Evaluative metering measures the exposure for the whole scene, centre-weighted metering measures the entire scene but gives greater 'weight' to the centre of the frame, while spot metering measures the correct exposure only for the subject in the centre of the frame.

Noise

In digital imaging, a form of artefact that manifests itself in grainy, blotchy areas of an image. Noise is usually caused by the use of high ISO settings in low light conditions on a camera with a small sensor.

Optimize

Reducing an image's file size by compression and/or reducing the number of pixels so that the image is of a suitable size to be used on the Web.

Pixel (picture element)

The basic unit of all digital images. Each pixel in a digital image has specific tonal and colour values.

PPI (pixels per inch)

The standard unit of measurement that governs a digital image's resolution.

Raw

An increasingly common type of file format used to store digital images. Unlike JPEG or TIFF files, which are subjected to in-camera processing to a greater or lesser degree, Raw files are unprocessed files and simply contain the information captured by the sensor.

Resolution

Broadly speaking the amount of detail present in a digital image. Resolution is measured in PPI (pixels per inch), and equates directly to the number of megapixels the camera's sensor is capable of producing. The greater the image's resolution, the larger the print it is capable of producing.

Sensor

The heart of all digital cameras. The sensor is the equivalent of conventional film in that it captures the light from the scene via the focussing lens. There are two common types of sensor, the CCD and CMOS sensors.

On the most fundamental level, both convert light in the form of photons into an electrical charge, which is then converted into a digital signal. Sensors vary dramatically in size, with larger sensors on the whole producing higher-quality images.

TIFF (Tagged Image File Format)

A type of file format used to store digital images. Compatible with most image-editing software, TIFFs, unlike JPEGs, can support layers, and 16-bit/channel colour. Also unlike JPEGs, TIFFs can be compressed without losing any image data (see compression). Once a popular format in many digital cameras, the large size of TIFF files has seen their popularity wane and the format is being generally replaced by the more efficient Raw format.

White Balance

A digital camera setting that enables the camera to differentiate between varying colour temperatures to ensure that the final image appears neutral.

Useful websites

Software

Adobe – www.adobe.com
Arcsoft – www.arcsoft.com
Corel – www.corel.com
FotoFinish – www.fotofinish.com
Microsoft – www.microsoft.com
Photo Explosion – www.novadevelopment.com
Roxio – www.roxio.com
Serif – www.serif.com
Ulead – www.ulead.com

Manufacturers

Canon – www.canon.com
Casio – www.casio.com
Kodak – www.kodak.com
Nikon – www.nikon.com
Olympus – www.olympus.com
Panasonic – www.panasonic.com
Pentax – www.pentax.com
Samsung – www.samsung.com
Sony – www.sony.com

Equipment reviews & forums

Digital Photography Review – www.dpreview.com
Digital Camera Resource Page – www.dcresource.com
DC Views – www.dcviews.com
luminouslandscape.com – www.luminouslandscape.com
Steve's Digicams – www.steves-digicams.com

Index

A

Adams, Ansel 6
adding borders 122-3
adding text 114-17, 127
adjustment layers 90-93
Advanced Blending 137
analogue cameras 10
anti-shake 138
Apple Macintosh 22-3
Apple Mac OS X 22-3
artefacts 138
auto exposure / auto focus lock
 button 33
auto exposure lock (AE-L), prosumer
 31
autofocus 138
auto/manual focus switch 33

B

Bayer pattern 14
Bibble 46
bit 13, 138
bit-depth 138
black and white 134-5, 139
blending modes 94-7, 111
 Advanced 137
 sharpening 97
borders 122-3
bracketing 138
brightness levels 52-3
Brush tool 132-3
buffer 138
burning 60-61, 92, 138

C

Camera Raw 46-7
Canon 10
 EOS 300D (Rebel) camera 10
 scanner 20
Cattrell, Peter 6

CCD (charge-coupled device) 15, 20,
 138
channel 138
chromatic aberration 138
Clone Stamp tool 64-5
cloning 64
CMOS (complementary metal-oxide
 semiconductor) 15, 138
colour
 adjusting 56-8
 boosting 56-7
 burning 60-61
 chromatic aberration 138
 dodging 60-61, 139
 RGB model 12, 13, 14, 46
colour cast 58-9
colour channels 12, 13, 138
colour depth 13, 20-21
colour filter array (CFA) 14, 15, 138
colour temperature 36-7, 138
colours 13
 in pixels 12, 13
 primary 13, 14
command dial 31
 digital SLR 33
compact cameras 15, 16, 17, 28-9
 ultra-compact 16, 17
compression 34-5, 138-9
computers 22-3
continuous shooting mode 33
continuous tone 139
contrast 54-5
converging verticals 82-5
converting to black and white 134-5
cropping 48-9
cross-processing 96
Cyber-shot 16

D

delete button 29
depth, colour 13, 20-21
depth of field 100-1, 139
Diffuse Glow 107
digital SLR cameras 10-11, 14, 15,
 16, 19
 controls 32-3
 and dust 19
digital zoom 17, 139
dodging 60-1, 139
Doyle, Arthur Conan 6
DPI (dots per inch) 139
dust 19
dynamic range 139

E

electronic viewfinder (EVF) 18, 31
Elements see Photoshop Elements
Elliptical Marquee tool 70-71, 86
e-mail 124-5
Epson scanner 21
equipment reviews, websites 141
ethics 6, 64
EVF/LCD button 31
exposure
 overexposure 31, 41, 95
 underexposure 31, 94-5
exposure compensation button 29,
 30

F

F button 31
Face Tagging 24
Feather 71, 73, 75, 100, 101
field depth 100-1, 139
File Browser 24
file compression 34-5
file formats 139
 JPEG 34-5, 46, 47, 129, 139

Raw 35, 37, 46-7, 140
TIFF 35, 46, 139, 140
film cameras 10
filters 6, 104-9
 colour filter array (CFA) 14, 15,
 138
 menus 106-8
 Photo Filters 104-5
 styles and effects 109
fixed-lens cameras 16-18
 prosumer 18
 size 17
 viewfinders 18
flash
 Auto 28
 compact cameras 28
 Fill Flash 28
 prosumer 18
 Slow sync 28
flash button 29, 31
focus
 manual 139
 soft 98-9
formats see file formats
Four-way Menu button 31
Frames 109
Fujifilm 18, 30-31

G

Gradient 110, 113
graphics 127
greyscale 139

H

hand tinting 132-3
high-key images 102-3
histograms 40-41, 52, 139
hot shoe 31, 33
Hue/Saturation 77, 91-3, 134-5

I

image-editing software 24-5
 trial downloads 25
 see also Photoshop Elements
information LCD display 33
ink 23
interpolation 15, 139
ISO (International Standards
 Organization) ratings 38-9, 139

J

JPEG (Joint Photographic Experts
 Group) files 34-5, 46, 47, 129,
 139

L

Lasso tools 74-5
layers 86-91, 139
 adjustment 90-93
 blending modes 94-7
 restacking 89
Layers palette 87, 111, 113, 116
LCD screen 18, 40
 digital SLR 33
 Nikon 29
 prosumer 31
Leica 10
lenses
 digital SLR 32
 Nikon 28
 prosumer 30
 types 17
 zoom 17, 18, 29
Levels 52-3, 54-5
light 36-7
Lighting Effects filter 108
Lumix 10

M

macro button 29
Magic Selection Brush 81
Magic Wand 72-3
Magnetic Lasso 77
manual focus 140
manual setting 17
manufacturers 141
Marquee tools 70-73
 Elliptical 70-71, 86
 Magnetic 77
 Polygonal 76
masks 78-80, 140
megapixels 14, 15, 140
memory card 140
menu button 29
metering selector 31, 140
Mezzotint filter 108
mode selector 28, 31
monitors 23
 and colour 13

N

Nikon 19
 controls 28-9, 32-3
noise 18, 140

O

OK button 29
on/off switch, automatic 28, 30
Opacity 113, 135
optimize 140
Outer Glow 117
overexposure 31, 41, 95
Overlay 96, 103, 113

P

Paint Shop Pro 94
Palette Bin 109
Palette Knife 107

Panasonic 10
panoramas 136-7
paper 23, 121
pasting 64
Pentax Optio 750Z camera 17
perspective 82-5
Photo Filters 104-5
photodiode 14, 15
Photoshop 24
 Camera Raw 46-7
Photoshop Elements 7, 24-5
 adding text 114-17
 blending modes 94-7
 borders 122-3
 colour cast 58
 colour control 59
 cropping 49
 emailing 124-5
 enhancing skies 110-13
 Face Tagging 24
 File Browser 24
 filters 104-9
 histograms 40
 Levels 52-3, 54-5
 Magnetic Lasso 77
 perspective 82-5
 Photo Filters 104-6
 printing 120-1
 Quick Fix 25
 rotating 50-51
 scanning 42-3
 Selection brush 78-81
 sharpening 62-3, 97
photosites 14
pixels (picture elements) 12-13, 141
 megapixels 14, 15, 140
 PPI (pixels per inch) 12, 13, 140
 and sensor 14-15
play button 29
Polygonal Lasso 76

postcards 114-17
PPI (pixels per inch) 12, 13, 140
presets 17
primary colours 13, 14
print size 12, 13 121
printers 22
 colour 23
 inkjet 22, 23
 laser 23
printing 12, 120-1
prosumer cameras 15, 18, 30-31

Q

Quick Fix 25

R

Raw files 35, 37, 46-7, 140
red-eye reduction light 28, 30, 32
removing unwanted objects 64-5
resolution 12, 15, 40
RGB colour model 12, 13, 14, 46
rotating 50-51

S

scanners 20-21, 42
 colour depth 20-21
 film 21
 flatbed 21
 resolution 20
scanning 42-3
selections 70-71
 Magic Selection Brush 81
 masks 79-80
self-timer button 29, 33
sensitivity settings 38-9, 139
sensors 14-15, 140
 A/D conversion 15
 CCD (charge-coupled device) 15,
 138
 CMOS (complementary metal-

oxide semiconductor) 15, 138
size 14, 15, 18
sharpening 62-3
 with blending modes 97
shutter release 30
 button 29
Sigma 10
silicon photodiode (SPD) 14
skies 110-13
slide show 126-7
SLR photography 10-11
soft focus 98-9
software, websites 141
Sony 16
Styles and Effects 109

T
Tamron 10
telephoto 17
text, adding 114-17, 127
TIFF files 35, 46, 139, 140

U
ultra-compact cameras 16, 17

underexposure 31, 94-5
Undo History palette 79
Unsharp Mask 62, 97, 106

V
verticals, converging 82-5
video 18
viewfinders 18
 digital SLR 33
 electronic 18, 31
Vivid Light 96

W
Warming Filter 105
web, saving images for 128-9
websites 141
 trial downloads 25
white balance 36-7, 140
Windows XP 23

Z
zoom, digital 17, 139
zoom button 29
zoom lenses 17, 18

Author's acknowledgements

Thanks to all those at Essential for providing me with the opportunity for doing this book, and for their help and support along the way.

Particular thanks to Stuart Andrews for his knowledge and editorial expertise, and to Nic, Max and Mia for their patience and photographic inspiration.

Picture credits

All photographs by Steve Luck, except the following:
p.10 (top) Canon Corp., p. 16 Sony Corp., p.17 Pentax Corp., p.18 FujiFilm, p.19 Nikon Corp., p. 20 Canon Corp., p. 21 (top) Epson, (bottom) Nikon Corp., p. 22 Canon Corp., p. 23 Dell Corp., pp. 28–29 Nikon Corp., pp. 30-31 Fujifilm, pp. 32–33 Nikon Corp.

For Essential Works

Project Editor	Nina Sharman
Editor	Stuart Andrews
Design Manager	Kate Ward
Project Designer	Michael Gray
Indexer	Hazel Bell